Photography Demystified
FOR KIDS

A Kid's Guide and Parent's Resource for Fun Learning Photography Together!

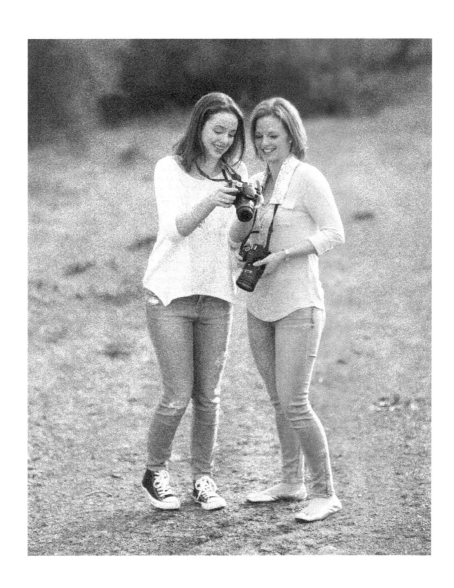

David McKay

As a thank you for purchasing my book, please click here to gain **UNLIMITED FREE** access to many photographic educational videos!

http://mckaylive.com/bonus

Unless noted, all images by Author David McKay
www.mckaylive.com/books

For orders, please email: mckaylive@yahoo.com

ISBN: 978-1-64007-740-9

This book is dedicated to my parents, Ross and Joyce McKay. I am forever grateful for your love, dedication, and constant encouragement in helping me to achieve my dreams.

I love you, Mom and Dad, and miss you every day. I hope you can see all that I have achieved because of you.

—David

If you carry your childhood with you, you never become older.

—Tom Stoppard

Contents

Introduction

I love that my daughter and I share a passion for photography. It's a hobby we can take wherever we go as a family. And it always gives us a reason to do something together. My photos tend to take in everything I see, but she sees all the little details. For that reason, I think her photos are more interesting than mine. Sometimes I pick up her camera to see what she's been shooting, and it always makes me smile.

—Robin (mom)

If it weren't for my mom's interest in photography, I might have never discovered my own spark in photography. Having the ability to look at life differently is a true gift that I am glad both me and my mom share. It has really been a fun process to learn together and, most importantly, to learn from each other. I love taking photos with my mom. Now we both pretty much have our Nikons glued to our hands!

—Shelby, age 14 (daughter)

The above messages, sent to me by one of my clients and her daughter, encompass the very reason I've written this book—learning photography with your child is fun and bonding—and taking photographs is something you can do together for years and years to come. It is EXACTLY why I wrote this book. This book will help you and your children learn photography in a fun and easy way, and it is something you can do together!

Photography Demystified—FOR KIDS! A Kid's Guide and Parent's Resource to Fun and Learning Photography Together, the fourth in the *Photography Demystified* series, is specifically designed for parents to read and follow with their children to create a fun-filled bond and hobby within the family. Many of the projects can be done even with the simplest of cameras, including those in smartphones.

This book is also **very much** for pre-teen and teenagers to be able to work with on their own, when needed, AND with their parents, so everyone can enjoy their time together!

This is a photography book that **children of all ages and parents alike will learn from**. *Photography Demystified—FOR KIDS* caters to younger children working with their parents in the simpler projects, but mostly to children in upper elementary school (ages 8–10), pre-teens (ages

11–12), and early teens (ages 13–14). ***But don't be fooled—this book will ALSO help the adult learn photography too!***

I wrote this book with the idea that parents and kids could have a fun time learning together. This book is NOT about the "perfect photograph" but rather the journey of learning photography in a fun way as a family.

Because this book is meant for children and their parents to explore and learn photography together, through a child's eyes, I've formatted it differently than the previous books in the *Photography Demystified* series. In this book, you'll find **over 50 photography projects** and **step-by-step instructions** on how to do them, as well as photographic visuals.

Having taught thousands of people photography and created an international best-selling series on the subject, I have been asked countless times about how to help younger children learn photography. So I've written this book.

Most photography books are not appropriate for children because they concentrate on technical information to such an extent that children's "joy" and "wonder" of depicting the world through photographs get lost in all the "photo jargon" of shutter speeds and F-stops. So, that's *not* what you'll find in this book.

My philosophy is that children need the freedom to be able to "see" and "share" how they see, and their wonder of it all should be acknowledged in a safe and non-critical way, first and foremost.

THEN, upon that foundation, other aspects, including some of the technical aspects, can be brought in to enhance their experience and increase their knowledge. We MUST not put our filters on them! The first rule is to help them develop a love for "seeing" through photographs.

This book is written for parents to experience with their children, according to ***HOW THEIR CHILDREN SEE THE WORLD.*** *Because of this, many of the projects in the book can be done with the simplest of cameras.* This is very purposeful.

This is NOT a book to guide parents on how take over, critique, and dominate what their child learns and sees along the way. I have written this book with a very clear purpose—rather than the parent dictating how the child should see the world, the child shares with the parent how they see the world, and in doing so, the parent will be lost for moments in their child's wonder and innocence so that the parent too will see "like a child." **You will see through a child's eyes!**

Photography Demystified—FOR KIDS! A Kid's Guide and Parent's Resource to Fun and Learning Photography Together has been written with the hope that the special sense of wonder children have, and parents cherish, can bring both together through the joy and learning of photography.

My hope is that your children will fall in love with "seeing" through the means of photography, and you, as a parent, will see through your children's eyes. In doing so, it will give you a bond so that

together you experience wonder, joy, and creation, all in expectation that this experience will provide a **precious, lifelong memory that is captured forever** through the photos you take.

How to Use This Book

Photography Demystified—FOR KIDS! A Kid's Guide and Parent's Resource to Fun and Learning Photography Together is divided into five separate and unique sections. Each section has a specific purpose and projects to help you and your child learn photography together.

Section One

Section one is based on very simple, fun projects that can be done with any camera, no matter how fancy it may be. **Even a smartphone camera will do just fine, and, in fact, I purposely used a smartphone during some of these projects with my own son!** Remember, the goal here is to have fun and be creative!

Section one is designed to have parents and kids, together, exploring, having fun, and learning to "see." Basic elements of composition are introduced in this opening section, but the goal here is to allow freedom of thought and expression without critical "rules" placed on the child.

As you progress through section one, you will find that you and your child will have already bonded over photography. Next it will be time to start bringing in more of the technical aspects. I purposely do not introduce these too early as I do not want your child (or you) to become frustrated and lose out on the most important aspect—having fun!

Section Two

As you move into section two, you and your child will learn about the basic elements of exposure, such as shutter speed, ISO, and aperture. You will learn how these elements allow you to control certain aspects of photographs to give you more creative options. If your child is younger, you will need to take the lead here and set up the camera, but still make sure to explain what you are doing and why. If your child is a little older, they may be the one to help you adjust the camera!

Expect to be working with semi-automatic modes where you have some control, but you won't be using 100% full manual settings.

My first book, *Photography Demystified—Your Guide to Gaining Creative Control and Taking Amazing Photographs*, is entirely devoted to teaching exposure control, composition, and many other photographic aspects. It is FILLED with this type of information.

As this book is a **stand-alone** book geared for children, from young ages to the teenage years, to work on together with their parents, you will find *select aspects from my first and second books* that will be *most* helpful to you if you have only purchased this book by itself. *It does not replace the previous books in the series, but it still offers substantial learning.*

For those that have already read my first and second books, GREAT! The select aspects from those books presented in this one will serve as review to help you better help your child! With that said, this book alone will get you well on your way to learning, regardless of any experience you may have.

Projects in section two will require a camera with manual settings in order to control the exposure. Most of the projects in this section cannot be performed on auto settings. If your child is a bit young for the manual settings, no problem, go ahead and skip to the compositional section, section three.

Section Three

Section three is all about composition and fun. Even at a young age, children can start to learn the guidelines for composing photographs, even if all they are using is a smartphone. You will explore the "Rule of Thirds," "Leading Lines and Curves," "Natural Framing," and MUCH more in the projects in this section.

Section Four

In section four, I will be bringing together all the exposure elements (introduced in section two) for full manual settings. This is an area that, once again, you may or may not want to head into as of yet. Much will depend on your child's and your own progress and how much desire you and your child have to learn these elements. Think of this section as a bonus of sorts because I know some children and their parents will want to complete the full manual settings and I don't want them to have to buy another book.

It is important to note—sometimes, as parents, we underestimate how much we think our children can comprehend. I was learning to shoot on manual settings at the age of 11!

Section Five

Section five gives an overall history of photography with mention of important innovations and innovators. It's something you and your child can study together as a way to deepen your knowledge of photography and challenge your own picture-taking.

Special Note about Age Appropriateness of the Book

Section five discusses how photography has influenced the world in both positive and negative ways. The goal of the section is for children to start to understand the power and influence of photographic images since the advent of photography to today. Please preview this section and take into account your child's level of maturity when deciding what events from you want to discuss with your child.

Perhaps you are asking yourself why I chose to include certain projects, emotional content, and the instruction of certain technological skills into a photography book that children and parents alike will learn from. My answer is that this book as a whole will cater to young children working with their parents with simple projects. However, most of the projects are geared to children in upper elementary school (ages 8–10) and pre-teens (ages 11–12) and early teens (ages 13–14).

In discussing the importance of photography I cannot, in good conscience, not take the opportunity to help our youth understand how photographs have helped humanity see not only the beauty around us, but also the events of our past that we must not forget, like, for example, the Holocaust, so they do not happen again. This discussion is geared for the older child and will be presented at a pre-teen, upper elementary to junior high level.

Please, as a parent, choose what is appropriate for the age of your child and what you feel is best. Without a doubt, young children will enjoy this book. However, children a bit older will greatly benefit because they have the maturity to explore the importance of photography for revealing the horrors and beauty of human history. I personally want them to know how important photographs can be and have been throughout history.

Who knows, you may have a future photographic journalist on your hands. There may be lessons they carry with them forever right here in the pages of this book. I can only hope!

Through a Child's Eyes

Through a child's eyes—most people have heard the phrase and equate it to the fact that children see different. They have not yet been filled with the clutter of thoughts of day-to-day life and complacency to the beauty that surrounds them, both of which can happen to many of us as we grow older into the adult years.

Young children have a sweet innocence about them, about the world in which we live, and about all the beauty that surrounds us. Children wonder and dream, see endless possibilities, and love unconditionally. They do not "see" through the filters we, adults, have become accustomed to.

Upper-elementary-school-age children, preteens, and teenagers are coming into their own, and, of course, want some independence, yet all the while still cling onto their parents for help and emotional support. Many are searching for a way to express themselves, and the arts make an excellent outlet for self-expression; plus, they provide a great way for a child to connect with adults—like their parents! *Of course, most of these young people already have their own cellphones with cameras, so why not channel some of that creative flow?*

My Story

When I was eleven years old, I watched an episode of the TV show *Eight Is Enough* (or maybe it was the *Brady Bunch*) on which one of the kids had a camera. He snuck around and annoyed his family by taking their pictures when they least expected it.

Although I do not remember the exact show or episode, I remember that it helped me realize that I had a longing to photograph and document. For my birthday I asked for a camera. My parents got me a Kodak disc camera. (Some of you reading this may know exactly what I am talking about in regards to that camera while others, most of you, in all likelihood, may not have any idea.) And—I was hooked!

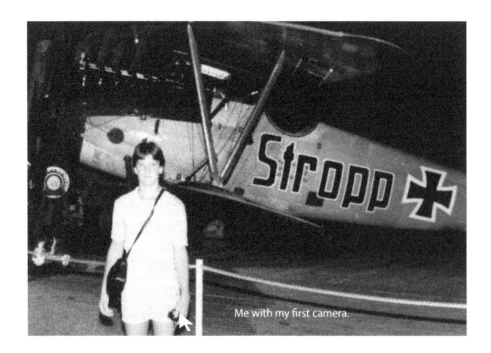

Me with my first camera.

Who would have thought that by seventeen I would be working in a photography store, and that by eighteen, I would have started my first studio? Fast forward, and here I am, at forty-seven, and my career has spanned almost 30 years.

I started by photographing portraits and weddings. I photographed my first wedding on April 18, 1988, at eighteen years of age, and went on to photograph hundreds of weddings over a 20-year span.

My real love for portraiture took over in 2001 after 9/11 when I gained a great understanding of the importance of life. At that time, I pursued my passion of photographing high-end, beautiful relational portraits of families. To this day, my wife, Ally, and I still have a portrait studio where we photograph families and individuals, as much as our busy photography academy schedule allows.

Here is a family portrait from our studio that Ally and I photographed together. It was taken the day the adoption of the baby was finalized for this family. For this reason, I love family portraiture to this day. Photography can be not only a "record" of a moment, but much more than that—a real piece of life history and emotion for those experiencing that life moment, like the family below!

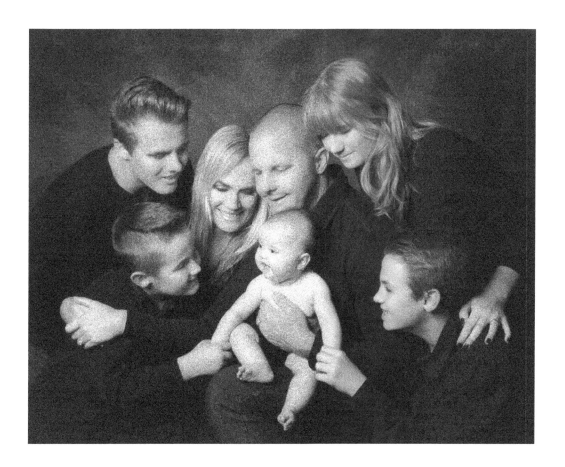

McKay Photography Academy was started in 2011 and, in just five years, has taken Ally and me all over the world, placed us in front of thousands of attendees at our seminars and classes, and, of course, inspired me to start writing the *Photography Demystified* series, which has now gone on to become an international best-selling series.

To think, all of this from one defining moment when I was inspired. Thank God my parents didn't dismiss my desire for a camera. That camera was the beginning of a life in photography that I cannot imagine being without.

This message also comes with a warning—in high school, when I moved from Richmond, California, to Grass Valley, California, I almost quit photography. When I started high school, I took a photography class, and my dad allowed me to use all of his Pentax camera gear. I loved it. However, when I moved my junior year and started a new school, my photography teacher, who I am sure was an excellent photographer, and I did not see eye to eye.

I remember being really proud of an image and showing it to him after I had printed it in the darkroom. The first thing he did was pull out a red marker and start marking all over my print. In retrospect, I am sure what he was trying to do was to help me get better and to hone my craft. However, his approach of marking up my image, handing it to me, and commanding, "Go do it again," without any help or explanation, almost ruined my love for photography. I ended up barely passing that class with a D. Rejection almost got the best of me.

The good news—I persisted. I went on to work at a camera store as part of my high school curriculum my senior year, and by the time I was eighteen, I was in business making a living photographing people.

The high schooler that faced rejection with his photography and barely passed a photography class went on to a career spanning three decades, photographed hundreds of weddings and families, traveled the world, taught thousands of students, and has written four photography books. To think, I almost walked away because of one moment . . .

So now you may be thinking, "Are you kidding me—this guy barely passed a high school photography class and now he is teaching and wants to help teach my kid?"

YES, that is EXACTLY what I want to do. I want to share my love for photography, how I overcame that big obstacle and went on to do what was in my heart, all that I am passionate about, and how you and your children can love photography too!

If I can impart to you and/or your child a degree of what I love in photography, help you both bond in the process, and help your child find a love for taking photographs, then this book is a success. I am not saying that your child needs to be the next Ansel Adams or *National Geographic* photographer, but—who knows?—maybe, just maybe that will happen. If, however, all that happens is you and your child find a common interest, have fun together, and enjoy the journey, I am thrilled!

Cameras and Gear

This book is filled with many projects that can be done with the simplest of cameras, **including a smartphone**. There is no need to go out and spend a lot of money in order to have fun with photography and with your child!

For some of the projects that get a bit more advanced as the book progresses to other sections, you will need a camera with manual settings as well as a basic tripod. **Please—do not let that concern you!**

If you do not own a camera with manual settings, there are PLENTY of projects offered in this book that you can do and enjoy. In fact, many of the projects were photographed with a smartphone and some of the attachments you see below.

For those that want to continue the learning and experience more, if you do not own a camera with manual settings already, I have shared a few of my favorite camera starter systems at the end of this book for you to consider acquiring.

For those that love iphoneography (that's the new term for taking pictures using a smartphone rather than a camera), I recommend a set of small attachment lenses that latch right onto the phone and can create some cool images.

These small lenses are fairly reasonable in price and can make a dramatic difference in your ability to capture images right from your smartphone. To see what I mean take a look at the projects "A Bug's Life View" and "Mystery Photos" in this book!

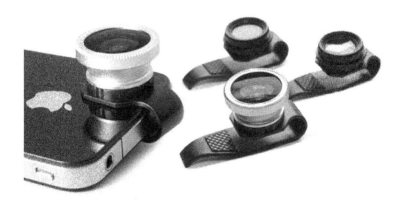

Project—Introduction to Photography

In this very first project, I want to help prepare you and your child to learn to have a real appreciation for photographs and why they are so important in our world and for each of us as individuals and as members of families. What this lesson entails is you showing your family's history through photographs to your child. The aim is to inspire your child to "see" the beauty of your home, community, and family, as well as the beauty of the Earth and what we all must do to cherish it.

Photography is all about capturing memories, places, and history. I ask that you show enthusiasm and also transparency in your emotions (you need to decide what your child is ready for) as you share your own family history through photographs.

Start by sitting down with your child and talking about photography and what it means to people. Show pictures from your phone and scrapbooks. It is very important to start by addressing photography first as something FUN you can do and do together.

Talk about how it is so great to have so many memories of your family and friends and pets. Explain how before computers and smartphones, you had to actually print a photograph and send it by mail! There was no such thing as email or texting photographs—or even the Internet, for that matter. This is where your child will look at you in disbelief!

Bring out that old shoebox or scrapbook of photos of you as a child and how you looked growing up. Talk about how your hair looked, what your clothes were like, and what your favorite memories of childhood are. Laugh together as you share. It is also okay to cry. Being transparent will help your child understand the importance of photographic memories, and it will make this experience into a significant memory for your child.

First day of Kindergarten. Nice pants!!

Yes, that is me!

If you have photographs of your family, especially ones of family members that have passed away or that may be living far away, pull those out and discuss how grateful you are to have them as a record. Talk about the people that are in the images and how much they meant, or mean, to you. Explain that by having the photographs you are able to hold on to something special that helps you remember moments in time.

Bring out the photographs of you and your child together and recall those fun times. Talk to your child about how the photos make you feel. **Ask your child, "How does seeing this photo make you feel?"** Help them understand that photographs are able to help us remember all the great times as a family and all the wonderful memories.

If your child is a bit older and you feel ready for it, discuss the importance of photography in our world today and how before photography, it was much more difficult for others to "see" what was happening or to see what their past or distant relatives looked like. Talk about current events and

how, because of photographs, we can see what is happening in the world today. Be sure to share the good things as well as your choice of some of the bad.

Be sure to talk about the importance of being able to have a visual record of our history and how photography has been used to create such a record. If your child is a bit older and you feel they are ready for it maturity-wise, discuss how photography helps us understand our past, the great things, as well as the very difficult things, like war and famine. Explore how photography not only gives a visual record but allows us to see what happened in the past, so it does not happen again.

Discuss how photography also allows us to see what others are going through and how that helps us as human beings have compassion and a desire to help those in need and that may be less fortunate.

Tip: Use magazines like *National Geographic* to show photographs of other cultures and parts of the world to your child.

Photograph of the Hadzabe tribe in Tanzania - 2016

TIP: Before moving to the next project, if you and your child seem interested enough already to jump right in and learn manual settings, composition, and other technical photography aspects, feel free to start there in section two. After that you can return to section one to complete these projects with your newfound knowledge.

However, there is no pressure to do so! This first series of projects can be completed with any camera. Remember—the point is to have fun, first and foremost!

About Participation and Creativity in the Projects

For the young child following this project list, I encourage parents to allow the child the freedom to photograph however they feel is easiest and at their own pace and level. For small children just enjoying the moment is prize enough.

For the child that is a bit older, parents should encourage them to take time with each subject they photograph and not to rush through each project. *The goal is* not *to see how quickly each project can be done, but to take time and explore and learn to "see."*

For instance, if you are photographing a boat, take time to photograph the boat from various angles. Photograph the whole boat and then just portions of the boat. The goal as a parent is to work together with your child to develop creativity and to encourage one another to look at the subject through different sets of eyes.

By doing this, you will quickly realize that many children have an incredible gift in how they see and perceive things. This can be a real eye-opener, even with what initially seems a simple project.

Section One

Simple, Fun Projects

Project—Photograph Objects That Start with Alphabet Letters

This is a straightforward, easy start to photography. The task—simply go through the letters of the alphabet and photograph a subject that starts with the letter. For example, if you are on the letter B, you could photograph a bug, a boy, a bee, or a boat.

You and your child should be as creative with your subject choice and how you photograph that subject as you can.

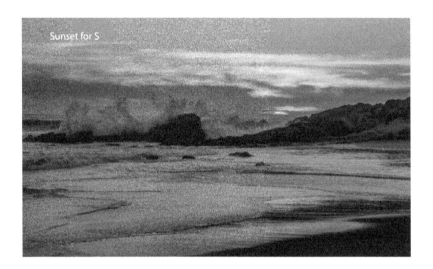

Project—Letters of the Alphabet

In this project, the idea is to take a creative photograph of items that look like letters and put an entire alphabet together. Trust me, this sounds easier than it is!

Have a day where you go together somewhere, like a downtown area where you can explore to find all the letters. Letters can be made out of anything as long as it is not a photograph of an actual letter! The trick is to be as creative as you can be.

Do you remember the alphabet game that people play in cars? Go ahead and make a fun challenge with your child to see who can find the most letter-like formations and each of you can take photographs of what you find. Then place all of your images together to form the alphabet.

Is the alphabet too much for you at this time?

Okay, here's another idea—work with your child to find letters to spell their name.

Project—A Bug's Life View

Get down on the ground and take your photographs from that low, ground-level angle. One of the things you will notice is that the perspective will be very different than most photographs you see. Something you can discuss with your child is why this is true.

I propose that it's true because we, as humans, are used to seeing and taking pictures, for the most part, while standing—from a "person's life view." However, because we are already used to this angle, it can be boring. By changing the angle and getting down very low (like a bug) the perspective of the subject is much different and, therefore, can create a different feeling to the photographs than we are used to seeing.

To be honest, I had so much fun doing this I could have kept going for a few hours all with my smartphone!

Project—Same Subject Different Views

Discuss with your child an object you both would like to photograph. Now each of you will take several photographs of that same subject.

Afterwards, go home and compare your images on the computer. Take time to talk about which images you like—that you took and that your child took. Decide which one you like best and try to explain why. Discuss how each of you could have made a particular photo or photos even better, but be careful not to judge. The idea is encouragement and learning!

Take a look at the following series of photographs with your child. The photos in the series are all taken of the exact same boat. You will notice that by photographing from different angles and also photographing the details, you get a very different perspective than if it was just one image of the boat. Discuss the differing perspectives of each photo in order to enhance and challenge your and your child's ways of seeing.

This project will help you and your child learn to take your time while photographing and to look for different angles and interesting parts of a subject. It will also help you and your child to learn "story-telling" through photographs.

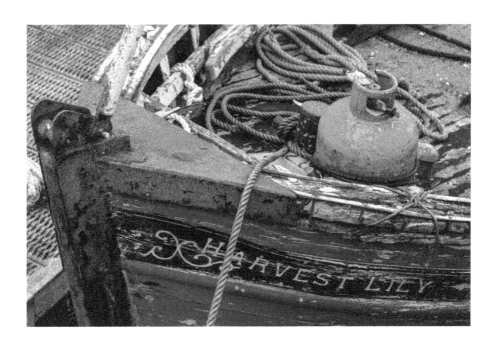

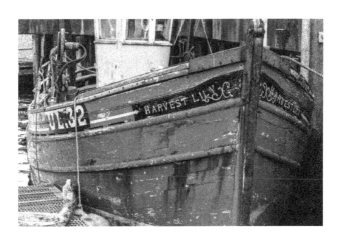

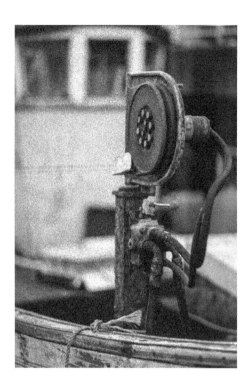

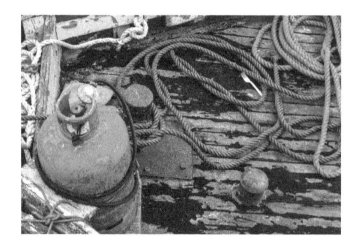

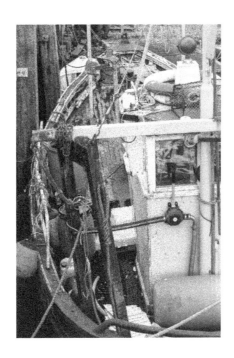

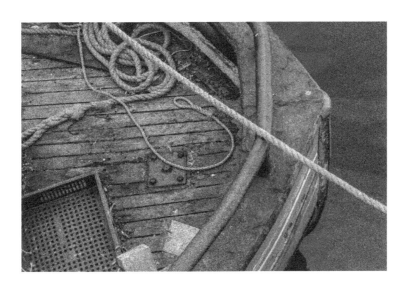

Project—A Day in the Life of Your Family

Yes, I know this is your family, and to your child it might seem boring. However, your family is unique and important. For this project, from the moment your child wakes until they go to sleep, your child will photograph their family throughout the entire day.

Explain to your child that they will document everything they see, even things that seem silly, like brushing teeth, eating breakfast, playing with the dog, or doing a chore. This is the story of a day in the life of your family, and your child will treasure it someday—assure them of that!

It is very important that for this project, your child does not worry about the "perfect" picture. This is all about documenting the day.

Make sure to review together the pictures your child took. You both could even take time selecting favorites and then show these favorites to the whole family to make a kind of "gallery talk" with your child leading the talk.

Project—A Day in the Life of Your Neighborhood

Explain to your child that someday, when they are grown and have kids of their own, they will want to show their kids where they lived, what the neighborhood they grew up in was like, and even things like where they went to school.

For this project your child will photograph their friends and neighbors. Tell the people being photographed that you are creating a "day in the life of your neighborhood" so that someday you have the memories of everyone you knew and all the places you found special in your neighborhood.

Here is the grocery store my parents owned until I was sixteen. The store is still there in Richmond, California, and is a huge reminder of my childhood!

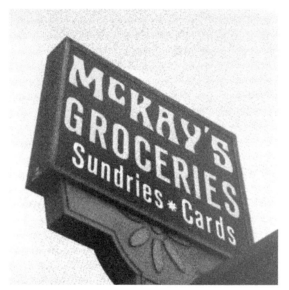

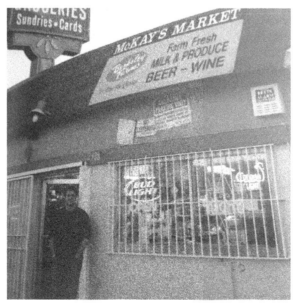

Project—A Day in the Life of Your School

This can actually be a great school project that your child can get extra credit for. First, your child should get permission from their teachers and let them know that they are learning photography and one of the projects is to photograph a "day in the life of your school." Your child can ask teachers if they can bring a camera to school and spend the day photographing everything and everyone.

Once your child starts photographing friends at school, I guarantee, it will get crazy! Remind them to make sure to try and photograph others as naturally as possible. Because once people realize they are getting photographed, they will want to pose all the time!

Make sure that your child reviews everything with the teacher and even offers to give them digital copies of the photographs, so the teacher can have photos for their memories too.

Project—Shrinking Objects

It is so awesome to do trick photography. You, your child, friends, and family will have a blast with some of the next projects, including this one!

Step 1: Get two friends or family members to do this with you and your child.

Step 2: Have one friend go way off into the distance, and have the other one stay close by.

Step 3: Have the nearby friend hold their hand out flat. Then have them move around their hand and have the faraway friend move also until it perfectly lines up so that it looks like the faraway friend is standing on the palm of the nearby friend's hand. Then take the picture!

Step 4: Switch it up and have the friends reverse positions!

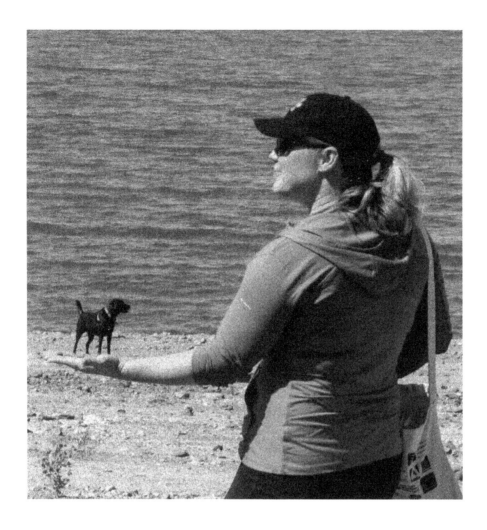

Project—Crazy Perspectives

Like in the previous project, the goal here is to see what you can come up with that makes the unreal look real! Take a look at these examples for some inspiration, and then see how creative you and your child can be!

The images below were taken by a friend, photographer Nicole Sepulvda on our photography tour in Scotland. By placing a toy dragon and unicorn in just the right spots, she made the fantasy world come to life!

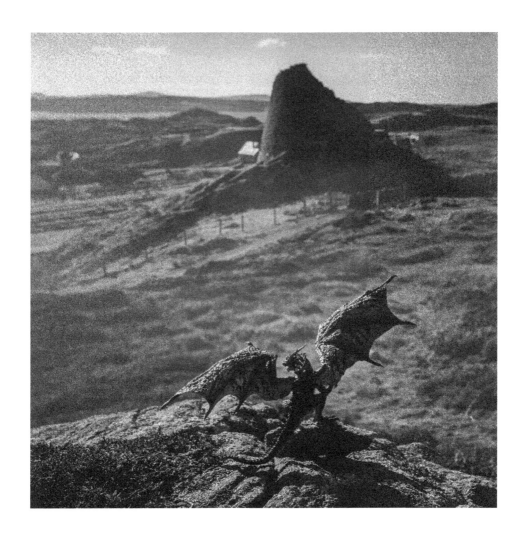

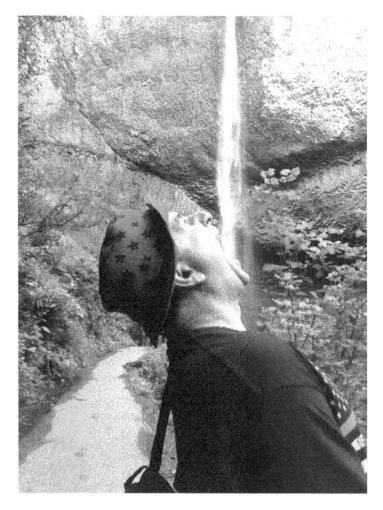

Above is my buddy, Alex, having a drink. He must have been really thirsty!

Project—Pets

Everyone loves their pets. Photographs of pets will become treasured memories someday that you and your child will always want to have. In this project, take time to photograph your pets.

Photograph them in many ways and also photograph their particular special characteristics, such as their eyes, nose, feet, and so on! This will make the photographs even more important, and you will have those cute details of their features forever!

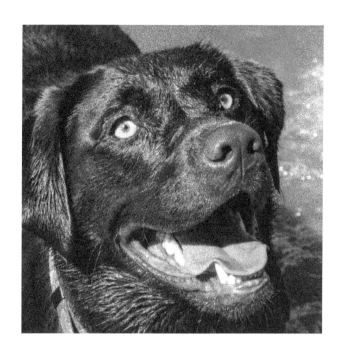

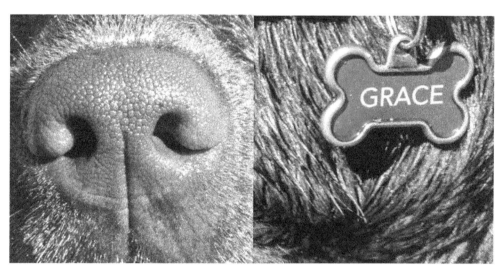

Project—Reflections

Reflections in photography are not only beautiful to photograph, but they also create a completely different "feeling" to the scene. I love photographing and capturing reflections.

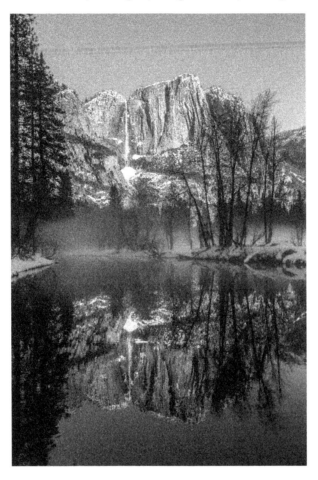

One thing about reflections is that you can see them in many forms. The obvious, of course, is in water. However, be sure that you and your child look around for reflections anytime you are out photographing.

Buildings, windows, and puddles all offer interesting reflections of subject matter. You just need to take time to look for reflections even when it may not be obvious they are around.

The reflection in the image below created a photograph that looks like something out of a Dr. Seuss book!

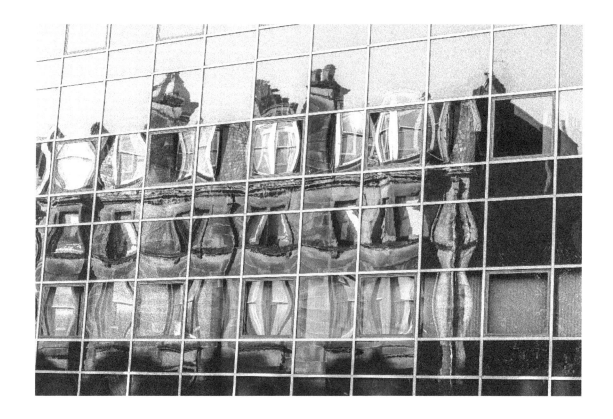

Sun reflecting in the water.

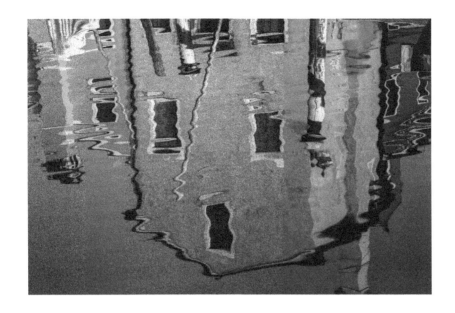

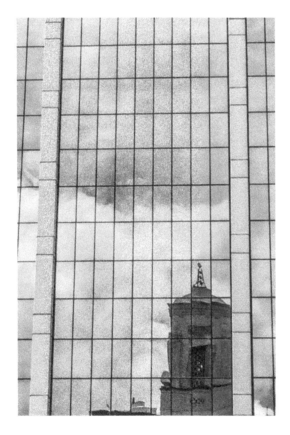

Project—Mystery Photos

Take close-ups and partial photos of ordinary objects and have family and friends guess what they are! Create a collection of your favorites!

Tip: These were ALL taken with a smartphone!

Can you guess what each of the photographs below is of?

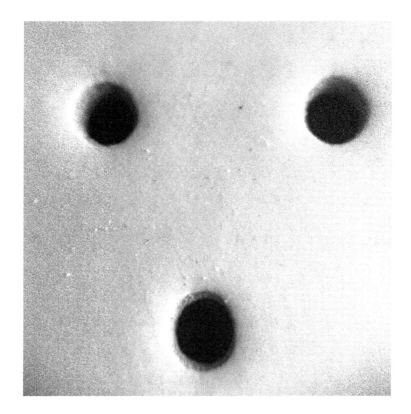

Answers are at the end of the book!

Project—Shadows

My wife, Ally, will spend hours looking for unique designs and shadows to photograph. She can be out at any time of day doing this because the changing variety of light creates different and unique shadow situations. She absolutely loves looking for details, shapes, and designs with shadows involved.

This is a great exercise in photography if you find that you are just out and about shooting and want to look for something different to photograph.

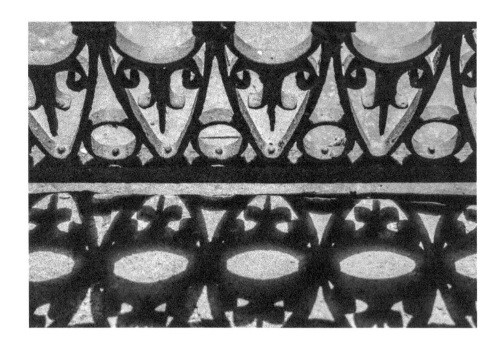

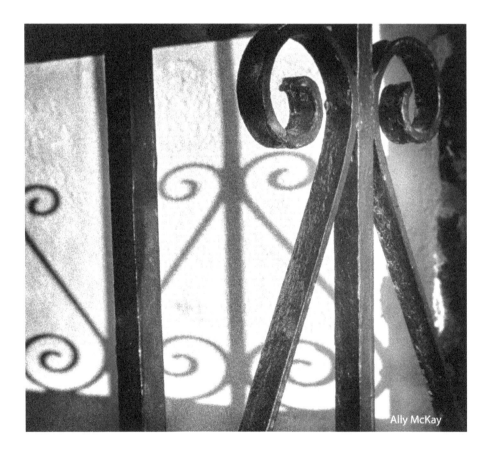

Ally McKay

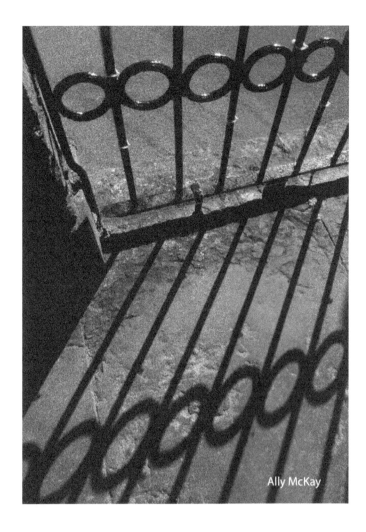

Ally McKay

Late in the afternoon is an excellent time to look for and photograph shadows. As the sun is low in the sky, long shadows cast from objects are at their best. Below in these images of the ancient standing stones of Callanish on the Isle of Lewis in Scotland, as the sun was setting, these wonderful, long shadows were being cast.

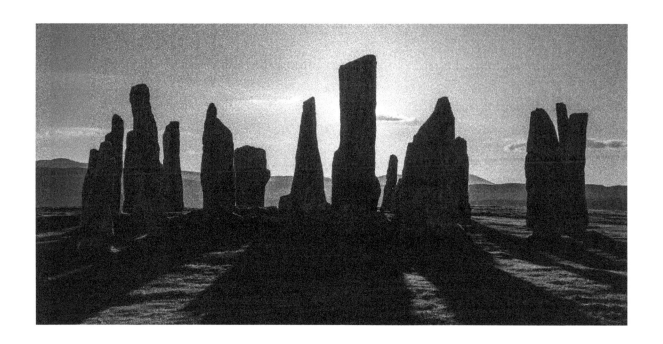

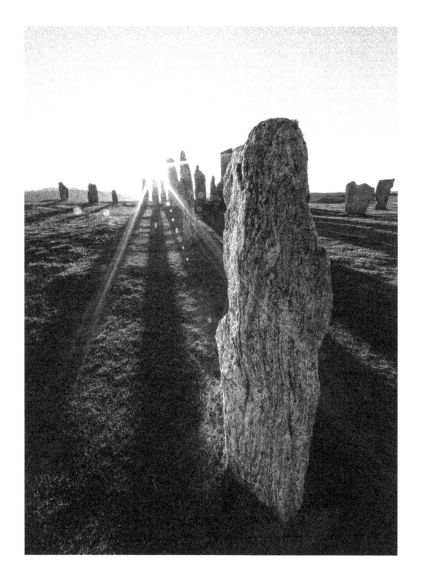

Project—Time Capsule

This is a project that will be years in the making but a treasure for sure some day! Together, list out some of the fun and favorite things you and your child want to remember about this time in your life. Consider things like your favorite places to go, people you like to visit, pets you love, your favorite clothing, games or sports you like to play, and more! Try to come up with an extensive list that really says a lot about this time in your life.

You can also use some of the photographs you took in the other projects, such as the "day in the life" series projects.

Print the images at a lab. Do not use ink paper from your home printer as it may fade over time. Place all the photographs in a sealed envelope or shoebox, and write on it, "DO NOT OPEN UNTIL THE YEAR . . . (5, 10, or 20 years from now)!!!" I know that is a long time to wait, but the longer you wait, the more valuable it will become!

When the time comes, open it up together! Your child may even have kids of their own by then. If so, the children can be there with you both when you open it, and then your child could do the same project with their kids someday!

Section Two

Basic Technical Elements

In this section, I am going to supply you with some technical information, so you and your child can get the most out of a camera. If your child is younger, you will find that some of this information may be too much for their comprehension at this time. In that case, just skip to the parts that you feel they are ready for and continue on. There are still plenty of projects they can do, and you can modify them as you need.

For those working with a pre-teen or teenager, this will be where you both can start learning real control of the camera. If you have read my first book, *Photography Demystified—Your Guide to Creative Control and Taking Amazing Photographs*, already, this section will include some information that you have already read. However, I have formatted it a bit differently for the younger audience, and it will also be a great review for you as well. Of course, it will help you to help your child progress.

Camera Design, Preparation, and the Correct Foundation

Just like many things in life, in photography it is important to make sure your foundations are set in order to ensure the most success.

You may be surprised to learn something you thought you knew already about the camera and to see how my approach to it may differ from what you thought. To this day, prior to ever going out and shooting, I take time to go through and make sure that my camera and gear are set and ready, and that my foundation for what I want to accomplish is strong. I never assume everything is already set where I want it to be; instead, I prepare each time I go out to photograph.

There is nothing worse than capturing great images and then realizing you blew it with something minor, such as not having the best quality set on your camera! Be sure to read each of these points. Also understand that while some of this is a bit "techy," it is necessary in order to understand how to get the very best out of your camera and to be able to take the best photographs.

Camera Design

First, let's cover a few basics about all cameras. All cameras contain the same basic elements; however, they may appear differently or work with minor differences. Nevertheless, the same principles apply. Here are the basic elements:

- Camera body or housing

- Light-sensitive material

- Shutter

- Lens

- Viewfinder

Each of these elements is defined below. It is important to note that I will go into depth about each one of these elements so that you obtain a greater understanding of them individually. Some of this may seem trivial; however, it is important to receive a background and education on how the camera functions. Setting the correct foundation is the key to creating incredible photographs. I want to make sure that your foundation is solid so that I can build upon it to give you the greatest benefits when it comes to learning photography.

Camera body or housing—the casing that contains the entire camera's working parts.

Light-sensitive material—an element on which an image is exposed, like a sensor or film. The shutter and the lens combine to expose light to register the image. In a digital camera, this element is known as the "sensor." An image sensor is the equivalent to film for film cameras.

Shutter—the part of the camera that opens and closes for a pre-determined amount of time to control how long light is allowed to enter the camera and expose the image sensor.

Lens—an element that collects light and focuses an image on the light-sensitive image sensor or film. Lenses are typically made of glass or transparent plastic. Glass lenses will produce better quality photos. Lenses can be bought at a wide range of prices based on the quality of the glass.

Viewfinder—what the photographer looks through to compose an image, and, in many cases, to focus the picture. A viewfinder is either the through-the-lens type or an LCD monitor, depending on the camera. Digital SLR cameras are usually through-the-lens types with an eyepiece while on more basic cameras the viewfinder is through an LCD monitor.

Types of Cameras

With the advancement of digital photography, the world has been opened up to a variety of types of cameras. It can be quite confusing and intimidating to stand in a store and see all of the cameras lined up. Many of them look identical, yet the price difference can be hundreds, if not thousands, of dollars between various models. So what is the difference? Why do two cameras that look identical sometimes vary in such extreme costs? This is why it is important to understand camera design and what the manufacturers are trying to sell to you, the consumer.

First, you must understand that to gain creative control, you need a camera that allows you to adjust the manual settings.

This means that you can control the three elements of exposure you will be learning about in the "Elements of Exposure" chapter. These elements are the ISO, the shutter, and the aperture. If your camera does not feature manual settings for these elements, you will not be able to make the needed adjustments to harness the light for what you want, rather than what the camera wants. You will find that manual control of these three elements is the key to being able to control the aspects of your photography outside of composition.

DSLR, Mirrorless, Point-and-Shoot—What Does It All Mean?

DSLR—Digital Single Lens Reflex

In the reflex design, light travels through the lens, then to a mirror that alternates to send the image to either the viewfinder or the image sensor. The viewfinder and what you see through it present an image that will not differ from what is captured by the image sensor.

Most DSLRs contain full manual settings. You also get the ability to change lenses with a DSLR. This is much better than built-in lenses as the quality and your creative ability to control and manipulate your images according to preference is far greater, resulting in better images. A DSLR camera also has no delay when pressing the shutter button. In other words, when you press the button, the image is taken instantaneously—no more missing the shot as you wait for the camera to take the picture!

DSLR cameras are typically more expensive but offer a much greater ability to control the results of the final images. There are several brands that manufacture exceptional cameras in various price ranges. Canon, Nikon, Sony, Olympus, Pentax, and others all offer great DSLR cameras. Canon and Nikon tend to be the most popular and are highly respected brands.

Mirrorless

Mirrorless cameras have a system with an interchangeable lens that does not feature a mirror reflex optical viewfinder, like in the DSLR. Mirrorless cameras are designed with the advantages of smaller size and lighter weight. They frame using what the sensor sees rather than using optical views with exchangeable lenses.

Mirrorless cameras make up the fastest-growing segment of digital photography at this time. This is due to the fact that you can get an amazing quality system with less weight than a DSLR in many cases. All the manufacturers are producing mirrorless cameras nowadays; however, Sony, Panasonic, and Olympus are in the forefront with Sony far ahead of the game as the leader in mirrorless technology and quality.

Point-and-Shoot

At the lower quality camera spectrum that can still give great results and even include manual settings are the point-and-shoot models. These are a great value. It is very important that if you purchase a point-and-shoot camera, you still get one that has manual settings available to use!

These cameras are geared towards the person who does not want to spend a lot of money yet wants the ability to gain some control over the photography. They do not include the ability to interchange lenses; however, they can be a low-cost, excellent quality alternative. They are also very easy to take with you anywhere!

Memory Cards

Here are some helpful tips and hints to keep the most precious commodity of your travels—your images—safe.

Develop a system—create an organized system for memory cards and do not waiver from it! Follow the hints below, set up a system, and be consistent. Once you have a set system in place, you will run a lot less risk of losing important photographs.

Keep non-downloaded cards unique—in your card carrier case keep all non-downloaded memory cards backwards and upside down. By doing this, you'll know the card is not ready for use. When you download AND back it up, at that time place the card right-side up again to signify that it is now ready to use.

Format your memory cards—before each use, INCLUDING the first use, format and make sure your card is clean. This makes sure the card is completely ready to go. Of course, only do this if all of your current images on the card are downloaded AND backed up! When erasing images, there is often still data left on the card, and it is not truly clean. By formatting the card, you are erasing the card completely and making sure it is clean, which results in better performance.

Download and back up memory cards every day—EVERY time you go out and photograph, the first thing to do when getting home is to download AND back up your memory cards! Use another hard drive, a second one, to be sure you always have a backup and NEVER erase your images until this is done!

The Elements of Exposure

This is where you will now learn to gain the creative control you want in your photographs. If you jumped ahead to this spot (I know some of you did), then after learning these elements, I encourage you to return to the projects in the book that you skipped and do them using your newfound knowledge and abilities. These projects are vital if you want to get the most out of your photography.

Many people get amazing camera systems yet never use them to their fullest potential, relying on the camera itself to get them the image they are hoping for by setting their mode dial to auto mode. Unfortunately, as most people find out, this rarely gives exactly the kind of picture that you had hoped for!

How Light Changes Everything

Photography is all about light. Light is valuable, and the key to creative control is learning how to control and work with light in your cameras and lenses! Sometimes you may find you have too little light. Yet, at other times, you will have too much.

I am going to teach you and your child the process of learning to work with light and your camera's manual settings to control the AMOUNT of light exposing the sensor to make a photograph.

Usually, the biggest reason that images do not work out is because of the amount of light available. For example, shooting a soccer game on a very bright day in a lot of light is much easier than shooting a basketball game in a low-lit gym.

You are going to learn that the key to stopping action is known as setting a fast shutter speed (more to come on that later). When the shutter opens and closes very quickly in an exact fraction of a second in time—to stop and capture that action—very little light can get in. If the day is really bright, you will find it is no problem to make the action shot because even though the shutter opens and closes extremely fast, there is enough light to handle it. In both a soccer game outside and a basketball game inside, you still need to stop the action in order to capture it in a photo, but because of the amount of light available, one is easier to do than the other.

It is situations just like this where the photographer needs to make decisions that a camera set on auto mode will not do correctly.

Yes, it will take practice and work; but, in the end, you and your child will acquire so much more ability to get the amazing images that you seek.

Project—Make a Sunprint

This project will give you and your child a sense of the power of light. Years ago, one of my first photography assignments in high school was to do a project very similar to this.

At the time, we would take objects into the darkroom and let a machine, known as an enlarger, expose light to the light sensitive paper we had.

Today, you and your child can do this project with special paper available at the craft store, and the sun will be your source of light.

1. Go to the local craft store and purchase sunprint paper and an acrylic sheet.

2. Collect objects, such as feathers, leaves, and other items, that will make cool and interesting shapes.

3. In a dark room, place a piece of the sunprint paper blue side up on a sheet of cardboard. Be sure the room is dark because any light can expose the paper.

4. Arrange the objects on the paper.

5. Place an acrylic sheet completely and firmly on top of the objects to flatten and hold them in place.

6. Take the sunprint outside and place it in direct sunlight for three to five minutes.

7. Remove the acrylic sheet and the objects, and then rinse and submerge the sunprint paper in a full tub of water for a minimum of one minute but up to five for a deeper blue finished piece.

8. Place your sunprint on a flat surface on top of a paper towel to dry.

Look at the example below and notice how beautiful it is!

Project—Pinhole Camera

In the very early days of photography, people used very simple cameras known as pinhole cameras. In a pinhole camera light travels through a small hole in a dark box to form a picture.

Amazingly, you too can create a very simple pinhole-like camera out of just a shoebox and a few items from the craft store!

In this project, you and your child will make a pinhole camera to see how light works to create an image. This is also an excellent science project for school.

Depending on the age of your child, adult supervision should be considered.

1. Get a shoebox and paint it black on the inside.

2. Using a pencil, punch a hole in one of the smaller ends of the box.

3. Cut a square in the other small end directly across from the pencil hole.

4. Cut the square two inches on each side.

5. Cut a square piece of wax paper that is three inches on each side.

6. Place the wax paper over the square in the box and tape the ends down.

7. Take the camera box to a room that is dark or very dimly lit. There should be a lamp in the room turned on (this is what you'll be sort of taking a picture of!).

8. Cover your head and the pinhole with a blanket. Make sure the end with the wax paper is on the end next to you and the end with the pinhole is facing away from you (the outer end).

9. Hold your pinhole camera in front of you with your arms extended out and aim it at the lamp.

10. Keep the camera steady until you see an upside down image of the lamp on the wax paper.

If you had a darkroom, you could use a photo-sensitive piece of paper, do this, and then develop the photograph! Wax paper shows you how it all works though!

The reason the picture is upside down is that when the light strikes the top of a subject, it reflects down into the camera lens. Rays that strike the bottom of a subject reflect upward. This creates an upside-down image in the camera!

In today's cameras, many of them have a mirror, and, as the light hits the mirror, the image appears right-side up in your viewfinder.

Exposure Overview

Exposure control means having the right amount of light to make a photograph that is proper and is based on the three major elements: shutter speed, ISO, and aperture/F-stop.

These three elements are the keys to understanding the EXPOSURE and CONTROL of the camera on the subject that you are photographing. All three elements work individually to contribute specific parts to a photograph, like stopping action, for example.

Yet, they all work together, at the same time, to control the amount of light needed for a photograph to be properly created. Once you and your child learn these three exposure control elements, the world of photography will open up to you in a way that is unlike anything you could ever do with a camera in automatic mode.

You will come to understand that you can use many combinations of these three elements or settings to achieve the same exposure (amount of light) yet come up with different results for other parts of your photograph.

For example, aperture/F-stop affects light AND depth of field. Shutter speed affects light AND motion. ISO affects speed, light, AND image noise.

The next few sections will describe how each setting works, what it looks like, and how to use it. At this point, you may be concerned as to whether you and your child can actually do this. I am here to tell you that, without a doubt, you both can! I have taught literally thousands of people my methods for understanding this often-complex system, so I have the experience to make it much easier to understand so that you can best teach your child and you'll both be able to get the results you want! Don't worry! I've got your back here.

Here is how I'm going to do this. I'll start by teaching you the exposure triangle. After that, I am going to break down each individual exposure element into bite-sized pieces, so you can manage them easily yourself and just as easily pass on the understanding to your child.

Your photograph is made of these 3 elements.

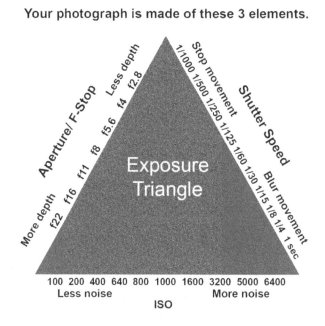

Now, as stated above, all three elements are always working together. Yet, rather than throw them all at you at once, we are going to learn each one by itself. This way, when I do bring them all together, you will understand exactly what is happening.

The Mode Dial

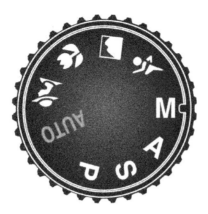

Cameras that use manual settings usually feature a mode dial similar to this one. If your camera has manual settings, but not a mode dial, that simply means the mode dial has been made into an electronic dial built into the system. Each letter or symbol on the dial places the camera in a different mode.

Scene Modes

These are the symbols in picture form, like the "running man," "the head," "the mountain," etc. Setting your camera on any of these is NOT the way to gain creative control in your photography. The camera manufacturer includes these to provide you a quick way to shoot various types of scenes. However, as mentioned, they are rarely very accurate, based on the fact that there are so many variables to every scene you may encounter.

Automatic Modes

In automatic (A) or program (P) modes, the camera relies on the light available to create an image. This holds the advantage in that the photographer does not have to think about or understand what is happening to create the exposure. HOWEVER, by always relying on the camera to do this, you put yourself at the HUGE disadvantage of not being able to create the images you might like to create. As we discussed, the camera does not know what you, the photographer, are trying to create. Therefore, it manipulates the exposure based on what it believes is the best use of all three exposure controls for the situation.

S or Tv: Shutter Priority

The S or Tv (time value) mode on your camera stands for shutter priority. The reason the word "priority" is being used is because you are choosing the shutter and allowing the camera to control the other settings. In a sense, you are prioritizing the shutter over everything else. In this mode, at

the very least, you are taking some control. Some control is better than none, so this is a great way to get started as you are learning to, at the minimum, control some aspects of your image.

In S or Tv mode, you are given control of the shutter speed. You simply choose the shutter speed you think is good for the image you are taking, and the camera will do the rest. We will discuss in detail when this is a good option and why it is not always the best option. As we've already touched on, shutter speed controls light and movement.

A or Av: Aperture Priority

The A or Av (aperture value) mode on your camera stands for aperture priority. As with the shutter priority mode, this is a semi-automatic mode. You simply choose the aperture or F-stop (they mean the same) you prefer, and the camera will take care of the other settings. Once again, some control is better than no control. Many instructors start their students off in this mode. I will explain the advantages but also the many disadvantages and precautions to be aware of when shooting in this mode. I previously mentioned that aperture/F-stop is used to control light and depth of field.

M: Manual Mode

M is the full manual setting. Here you can control all three elements in the triangle: aperture/F-stop, shutter speed, and ISO. This is where you truly gain full creative control. This is really what you want to learn. My goal with this book is to get you off of auto modes and into full manual. With that, you will truly experience being able to capture photographs the way you want. Sure, it will take some practice, but the advantages are well worth it! You MUST be on the M setting to change the functions that we are going to discuss in detail.

Project—Locate Your Mode Dial

If you haven't already, locate the mode dial on your camera. It should look similar to the example above and usually is right on top of the camera. You will only have this if your camera has manual settings.

Some cameras that do have manual settings but are smaller ones sometimes have the manual setting in the electronics. You can find this out by referring to your user manual or googling the camera model.

The Exposure Triangle

Your photograph is made of these 3 elements.

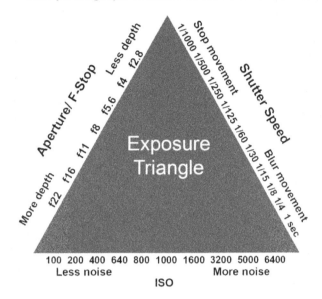

You will notice that the triangle is made up of three elements: shutter speed, aperture/F-stop, and ISO. They ALL work with light. You will also notice that each element has another character that it controls, like movement or depth of the image. This is a key to understanding creative control!

A change in one of the elements will impact the others. This means that you can never really isolate just one of the elements. All three work together to create the right amount of light exposure on the image sensor. Yet, each one has its own unique function. When changing one, you always want to keep in mind that the other two elements will likely need to change as well.

Here is an overview each of the three exposure elements. Now remember, I am about to break each one down into even more bite-size pieces following the overview.

Shutter Speed

A *time-value* represented by the amount of TIME the shutter opens and closes to allow light to reach the sensor.

Aperture, F-Stop

These two terms mean the exact same thing. Some photographers prefer one term over the other. Your aperture/F-stop setting controls how much light comes into the sensor through the opening of the lens as well as depth of field.

ISO

A rating of *sensitivity of light* used to expose the sensor.

Remember, in any image, you are using a *combination of ALL three exposure elements*. The particular combination of the three you choose depends on the situation and the light available. This is a big part of what you will be learning!

As an example, you may need a fast shutter speed to stop action. This may require a larger opening of the lens (small number F-stop) to compensate for the lack of time the shutter is allowing light in.

Or, you may want the images to show a lot of depth (sharper from front to back). This requires a larger number F-stop (less light), and that may mean a slower shutter speed to compensate for the light.

In each of these situations, your ISO setting will be chosen accordingly as well.

Shutter Speed

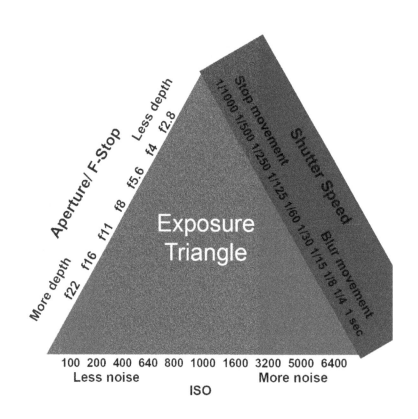

The shutter speed is a time value you set on your shutter to control light as well as to control movement in an image. The LONGER the shutter speed setting, the MORE light comes into the sensor. Yet, motion is not stopped. The FASTER the shutter speed setting, the LESS light comes in, but action can be stopped.

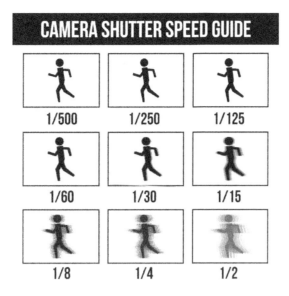

Project—Locate Your Shutter Control Dial

Find the control for shutter speed. This will be a dial on the front or back of your camera if you own a DSLR. Your camera must be on M for manual. Do not worry YET about making adjustments. Simply locate the dial and understand that you can change shutter speed with it.

On a Nikon, this will be the dial on the upper-right back.

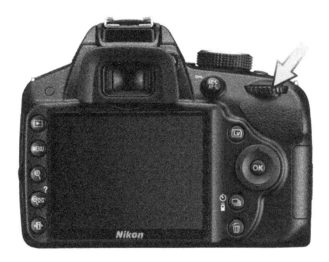

On a Canon, this will be the dial on the upper-right front.

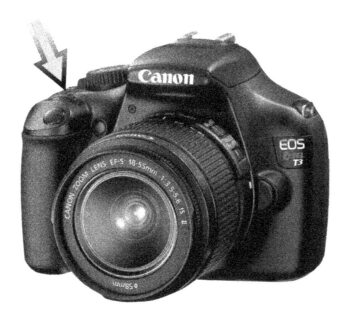

Shutter Speed Scale

This symbol that looks like a quote denotes you are in seconds

30" 15" 10" 5" 3" 1" 1/2 1/4 1/8 1/15 1/30 1/60 1/125 1/250 1/500 1/1000 1/2000 1/4000

Slow Shutter slows motion
lets MORE light in

USE TRIPOD
under 1/60th

Fast Shutter stops motion
lets LESS light in

Today's cameras are capable of incredibly fast shutter speeds. It is not uncommon for cameras to go to 1/4000th of a second or even higher, such as 1/8000th of a second. Think about that, 1/8000th of a second! That is fast enough to stop a hummingbird in flight.

Yet, a fast shutter speed opens and closes so quickly that very little light is able to come in. We are talking about a fraction of a second! Remember, each element controls light AND another character of the image. For the shutter, that is movement and motion. The shutter speed is going to be what we prioritize when we are photographing any type of movement or action.

You should now know where the dial is to change shutter speed. As you roll the dial left, you will notice that the numbers go from larger to smaller. These numbers are fractions of a second. Some cameras show the numbers as an actual fraction. Others however, show a solid number, but it is STILL a fraction of a second. For instance, one camera may show a 2000th of one second as a fraction like this 1/2000 while another camera may simply show it as 2000. They are the same.

Now as you scroll the dial left, there comes a point where the fractions turn into seconds, and the numbers start to get larger again. Seconds will have a symbol that looks like a quotation mark ("). For instance, 15" is a fifteen-second exposure and 20" is a twenty-second exposure.

Project—Shutter Priority

Set your camera to the S or Tv (shutter priority). Take your ISO and place it on auto. (JUST for now). Refer to your camera menu on how to choose ISO if you have not yet already figured that out.

Now experiment with the various shutter speeds and see the results you get. First, try stopping action with various shutter speeds. This photograph below was taken at 1/3200th of a second! Notice how all of the water is stopped in action.

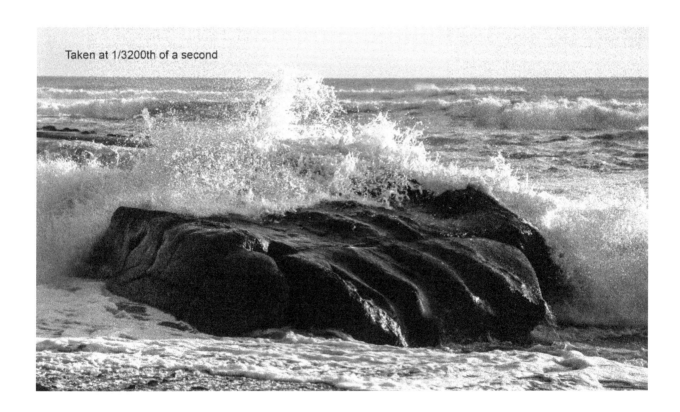

Then, try really long exposures with a tripod or as the camera is on a set object, like a rock, and see what you can do!

You will need the light to be lower, such as during evening or dusk, otherwise a long exposure will be too bright as too much light will be reaching the sensor.

In the photograph below of the waterfall, look and see how smooth the water is. This is because the exposure was for one whole second. That is a long time in photography terms. During the exposure, as the water continues rushing, it appears smooth.

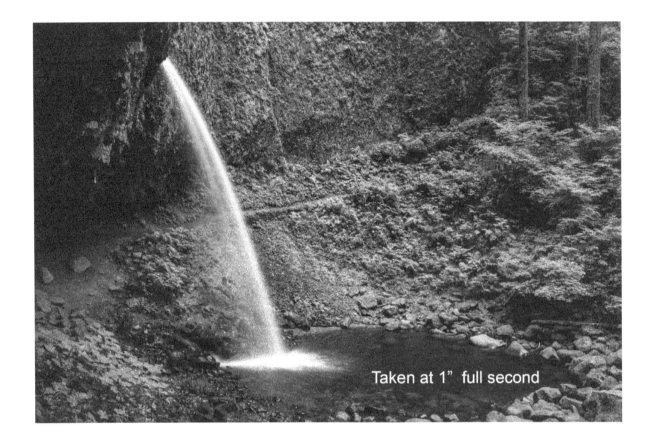

Taken at 1" full second

Aperture/F-stop

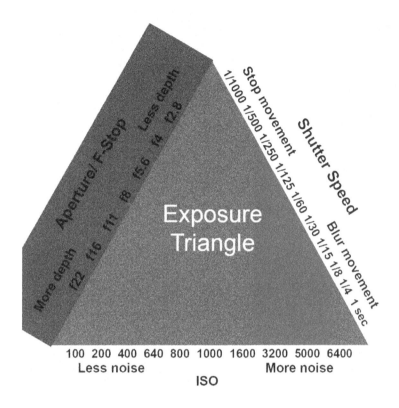

Aperture is the opening of the lens that determines how much light is let in to expose the image sensor.

Many people get confused with the aperture setting because the BIGGER the number, the smaller the opening to let light in while the SMALLER the number, the bigger the opening to let light in!

The SMALLER the F-stop number, the MORE light comes in. The LARGER the F-stop number, the LESS light comes in.

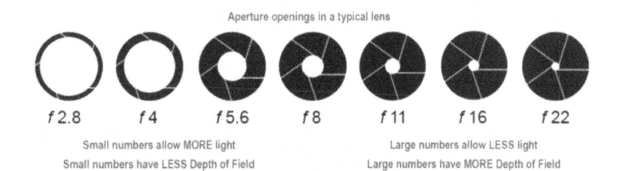

Think of the aperture as an eye. After all, that really is what a lens represents. When you are in a dark setting, you may need a bigger opening to see better. This is just like the pupil of your eye, which expands to let more light in. The opposite can be true in a bright setting. Here your pupil would close down to a small opening so not as much light comes in.

Changing your aperture setting can be a bit tricky depending on the camera system. Usually cameras feature a ONE- or TWO-dial system. See the images below to help with your system.

Nikon Users: Nikons have the dial on the upper-back right, as shown. This dial works to change the shutter speed. No matter what Nikon DSLR you own, you should see this dial.

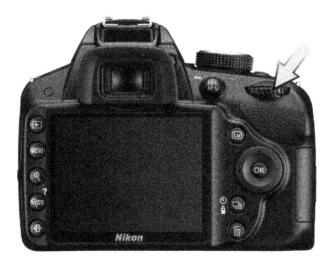

Now, look at the front of your camera, by the grip, to see if there is a second dial. **This is simply the dial that will change the aperture/F-stop.**

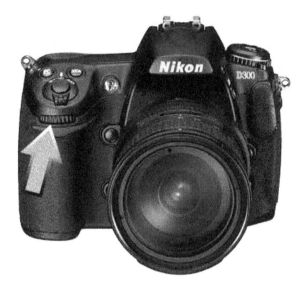

If your Nikon has a dial in front like this, this is where you change the aperture/F-stop.

If you do NOT see a dial on the front, like in the one above, that means your Nikon is a ONE-dial system. In this case, the dial that changes your shutter is SHARED by the aperture. **To change the aperture, press and HOLD the button on the top that looks like this.**

While this button is held down, use the same back dial that changes the shutter speed, and it will now change the aperture.

WARNING: If your camera has the *TWO-dial system*, this button is used for something else as well called exposure compensation. I HIGHLY recommend not depressing that button and using it until you are more familiar with camera settings. For the two-dial user, simply use both dials.

Canon Users: Canons all feature the dial on the front right, as shown below. This dial works to change the shutter speed. No matter what Canon DSLR you own, you should see this dial.

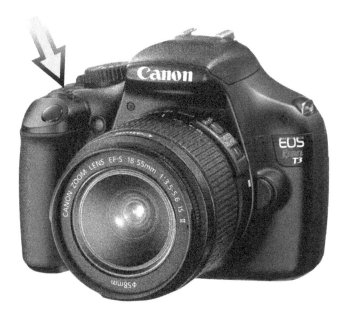

Now, look at the back of your camera. If you see a second dial, this is simply the dial that will change the aperture/F-stop.

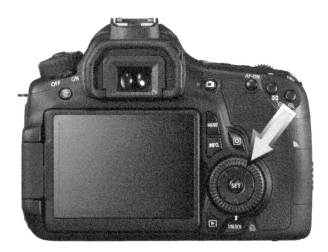

If you do NOT see a dial on the back, like in the image above, that means your Canon is a ONE-dial system. In this case, the dial that changes your shutter is SHARED by the aperture. To change the aperture, press and HOLD the button on the back that looks like this and has an Av next to it.

While this button is held down, use the same dial that changes the shutter speed, and it will now change the aperture.

WARNING: If your camera has the *TWO-dial system*, this button has a second use for something called exposure compensation. I HIGHLY recommend not depressing that button and using it until you are more familiar with camera settings. For the two-dial user, simply use both dials.

Other systems: Almost all DSLR systems are set up either like a Canon or a Nikon with a one- or two-dial system. If there is only one dial on your camera, simply look for the plus/minus button. Of course, you can refer to your manual as well.

Project—Change Your Aperture/F-stop

Scroll each way with your aperture and see how the F-stop changes. Your F-stop can ONLY GO AS FAR as the lens allows. A lens that only goes to f4 cannot go to f1.8, for example. It is your lens, NOT your camera, that allows the F-stop openings. The more expensive lenses allow in more light with F-stop settings, like a 2.8 or 1.8, for example.

Depth of Field

Just like the shutter, the aperture ALSO has two functions, the first being that it, like the shutter, allows light in to expose the image sensor, based on its opening size. The second is depth of field.

Depth of field is the range of distance over which objects appear in sharp focus. The lower the number, the LESS depth of field, and objects will not be as sharp behind or in front of your main subject. More light is also let in through the lens.

The HIGHER the number, the MORE depth of field, and objects behind or in front of the main subject will be sharper.

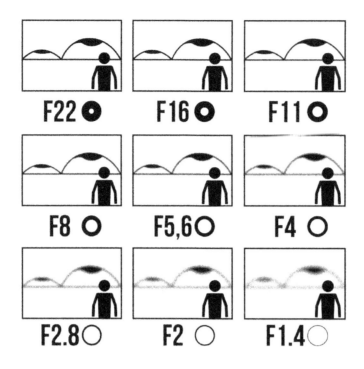

Project—Aperture Priority

Set your camera to the A or Av (aperture priority). Take your ISO and place it on auto (JUST for now). Refer to your camera menu on how to choose ISO if you haven't already figured that out. Now experiment with the various aperture/F-stop settings and see the results you get. First, focus on something close and use a small number F-stop. Then change the F-stop to a big number, like f22, and see what a difference this makes!

Remember—little number equals little depth, and big number equals big depth.

Depth also depends on how close you are to your subject AND how far away your subject is from the background. In other words, you can also increase depth by bringing your subject out away from the background.

Look at the two images below. The first one was taken with an F-stop of 22. The second one was taken with an F-stop of 4. Notice how much sharper the first one is as you go farther back towards the cannon balls compared to the second one.

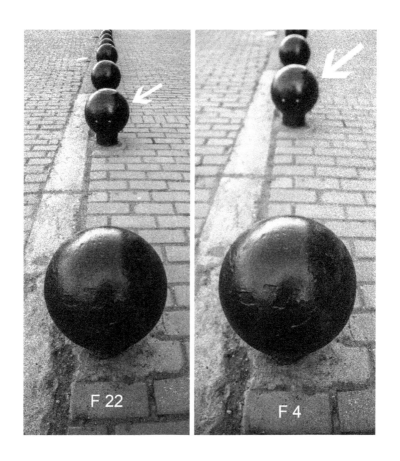

F 22

F 4

ISO

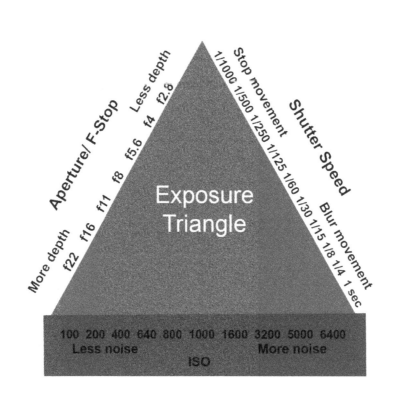

The general rule of thumb is that you want to try to use the LOWEST possible ISO you can at any given time. The reason is, the lower the number, the better the quality of the image. The higher the ISO setting, the more "noise," which refers to a grainy texture, you will see in the image, which makes a lesser quality exposure.

Typically when I'm taking pictures, of the three exposure elements, it's the ISO that I determine first. I choose what I think is going to be the ISO that I can get by with and then work with the other two elements, shutter speed and aperture, to get my exposure. If I cannot obtain what I need, I can then increase the ISO.

The more light that is available, the LOWER the number you need. Typically, on a bright sunny day you can use 100 or 200 ISO and still get plenty of light for the other settings of shutter speed and aperture. The darker the circumstances, the higher the ISO needs to be, but this results in a loss of quality. However, you can still use lower ISOs IF you accumulate light over a long period of exposure.

When you're working in low light situations and you're working with action, you may find that you need to increase the ISO to a higher degree to capture the action because your shutter speed is moving so quickly, and, therefore, you need to make your ISO more sensitive to light.

Common ISO Settings

ISO 100 (for some Nikons it's 200) – Best quality for good, bright situations, like outdoors on a sunny day or with flash (adding light).

ISO 400 – Good all-around, for example, indoors with available window light, fast moving sports, or overcast days.

ISO 800 – Lower light situations, mostly indoor and at dusk.

ISO 1600 and higher – Very low light, like candle light, fireplace, theatres, or concerts. Lowest quality.

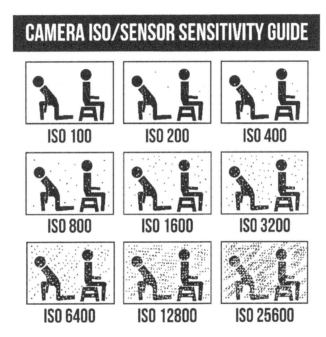

Project—ISO Changes

Go back to your ISO settings and take it off auto. Scroll through the various ISO settings and see the range that is available on your camera. As we move into full manual settings, you will be adjusting your ISO as well.

If you are struggling, it is OK to use auto ISO as you learn. However, eventually, you will want to control this element as well. In fact, setting the ISO to auto as you are learning your shutter speed and aperture can be very helpful.

Project—Lots of Photography Using Priority Modes!

Now it's time to have some fun! Before trying to work in full manual and bringing all three elements together, which I will teach you soon, I want you and your child to go out and take a ton of pictures. Go crazy photographing everyone and everything! HAVE FUN WITH YOUR CAMERA!

I want you to use the priority modes shutter priority (S or Tv) and aperture priority (A or Av). For now, just put your camera on *auto ISO*.

I want you and your child to go out and photograph all kinds of action using *shutter priority* mode. Try stopping action, blurring action, capturing friends jumping, and whatever else you can think of.

Try using the different shutter speeds to see what you can get. Try fast shutter speeds to stop friends on their bikes or skateboards, and try slow shutter speeds to see how the action blurs.

Use the *aperture priority* and try the different F-stops and see what differences you see. Get really close to a subject and use a small number and see how the background falls out of focus. Then, use a big number F-stop and see the difference!

Have a blast photographing everyone and everything you and your child can think of. The coolest thing is discovering that by using the priority modes you have WAY more control than on any auto setting—yet they are very easy to use. Simply remember—use *shutter priority* for action shots, and use *aperture priority* for depth-of-field shots. Simple—and you can do it!

> TIP: This is a time when I really want to encourage you as a parent and your child to take a break from too much heavy technical stuff and get out there and do the above. If all you ever do is work in a priority mode like this, you have way more control than most people ever realize they can get. Your results will speak for themselves!

Project—Panning Using Shutter Priority

Panning is a way to make a subject look like it is moving really fast. Sometimes your subject really is moving fast, so panning gives a sense of motion to your image.

If you are photographing a moving object, like a car or child running, as an example, consider using this technique to create that sense of movement and motion rather than just stopping the action totally.

When you are moving the camera with your subject, the background, which is stationary, will be blurred due to your movement. This gives the sensation of speed and motion blur.

- Panning is moving the camera in <u>synchronization with your subject as it moves</u>.

- To depict movement, the shutter must be at least 1/60th of a second or slower.

- The slower the shutter speed, the harder it is to keep your subject sharp.

- A slower shutter will depict more feeling of movement.

- For very fast subjects, like cars, try starting at 1/60th of a second.

- For slower subjects, start at 1/40th of a second.

In the image of the car below, taken in Cuba, notice how the background is blurred giving a sense of speed to the car.

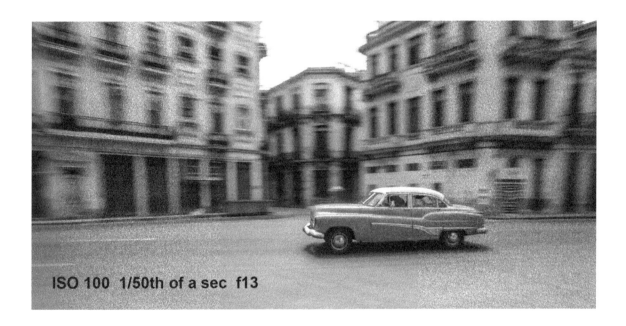

ISO 100 1/50th of a sec f13

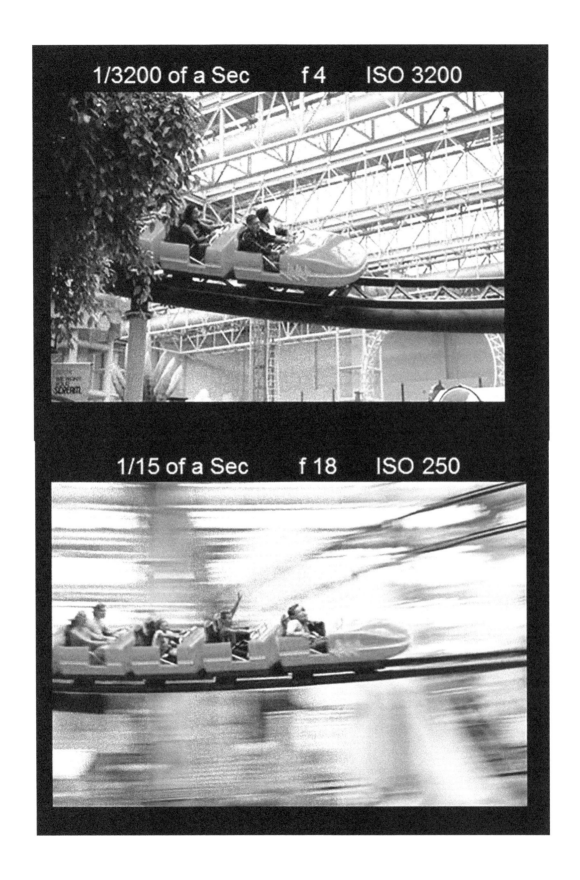

When doing a panning technique, rather than working to handle your exposure constantly, I recommend using "shutter priority," choosing your shutter speeds and letting the camera choose the aperture for you. By doing this, you will allow yourself to focus on the shutter speed and what you are trying to accomplish rather than the perfect exposure. If you need to, it is okay to use auto ISO as well. The idea is to be able to really concentrate on what you are trying to accomplish rather than being bogged down by all the settings.

1. Set your mode dial to "shutter priority" (Tv or S).

2. Set your ISO to "auto."

3. Start with a shutter speed of 1/40th of a second, and "pan" with the car as it moves by.

4. Keep doing this while adjusting your shutter speed until the desired result is obtained.

Project—Zoom the Camera

Other ways you can depict motion are to use your zoom during the exposure. As the shutter is pressed, quickly zoom your lens out and see what you can create! It helps to slow the shutter speed down. Try different shutter speeds and changing the rate at which you *zoom in* OR *out* and see what different images you can create!

1/13 of a sec F 13 ISO 100
With a ZOOM!

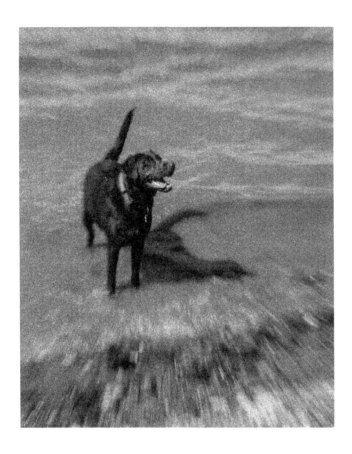

Project—Rotate the Camera

Now, let's try a different "twist"! As you are taking your picture, rotate the camera.

What I mean by this, is to simply turn the camera as the shutter is being depressed. If you turn the camera in the counter direction to the moving subject's direction, the feeling of movement and speed will be greater!

Try various shutter speeds and change how fast you rotate the camera to see what different effects you can come up with.

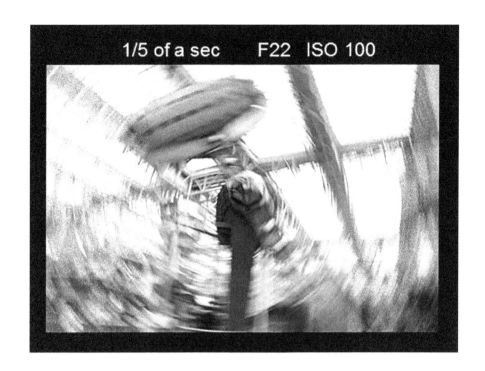

Section Three

Fun with Composition

The goal in creating amazing photographs is not to just get the elements of exposure correct; it is also to get great composition. Composition refers to the placement or arrangement of the visual elements in your photograph. By making sure the composition is excellent, you can make much more of a visual impact with your images.

I have seen photographs that are very good with their exposure, but because the composition was not very good, the photograph was not nearly as impactful as it could have been. Excellent composition makes the difference in whether your photograph is going to be amazing or not, outside of a good exposure. It is an element that determines how the viewer will actually look into the photograph and move around the image with their eyes.

By using various rules of composition as shown and taught in the upcoming projects in this section, such as Rule of Thirds, Space, Leading Lines, and more, you can take your photography to a stronger level.

In fact, if all you ever did was shoot pictures on your phone, composition is the one thing that will set your images apart from everyone else's! That is how important it is!

Lenses

What Do Lenses "See"?

Each lens has a specific function and you will find that there is no perfect lens. Lenses come in various lengths known as focal lengths. The focal length represents the distance light travels from the lens to the camera sensor.

The lenses you use make a difference in what you will be able to capture. For instance, telephoto lenses help bring faraway subjects closer, where as a wide-angle lens captures a much wider area of the frame. Lenses affect composition in that each lens has a very specific purpose and allows you to compose your images uniquely and differently for each subject being photographed.

The smaller the millimeter (mm) numbers, like 10mm or 16mm, the wider the view. The bigger the mm numbers, like 200mm or 300mm, the longer the lens and the closer you can photograph subjects that are farther away.

Look at the two photographs below. These were each taken from the exact same spot, but the resulting compositions are not at all the same. Notice how differently they depict the scene, based on the focal length of the lens! This shows you how a wider angle allows the depiction of a great amount of the scene and how a long telephoto can be so powerful that you can zoom right up into the double arch so that a person becomes visible—if you look closely!

Let's take a look at some examples of lenses, what they do, how they "see," and how they allow you to create various compositions of your subject.

About Some Lens Types

Wide-Angle Lenses

- Great for tight corners in rooms

- Great for wide scenery

- NOT GOOD for portraits because the perspective is skewed and, therefore, can make people look much heavier than they truly are. This can be great if it is fun, like the cow depicted below; however, not so great in other circumstances!

- Perspective is skewed

Wide-angle lenses are some of my favorites. I love using a wide-angle lens not only to see more but to help take my viewer on a journey through the image. The idea is that rather than focusing in tight on the subject, using a wide-angle lens allows my viewer to "step into" my image with their eyes and "journey" through the image to the main subject.

In the photograph below, I pointed the camera right down to just in front of my feet. This makes it feel like you can just walk right "into" the image! This does not mean that you should include your toes in your photographs, but you can get the camera to where the frame is just outside your toes being in the image. Be sure to also tilt the camera up at a bit of an angle to get the horizon in the distance in the frame as well.

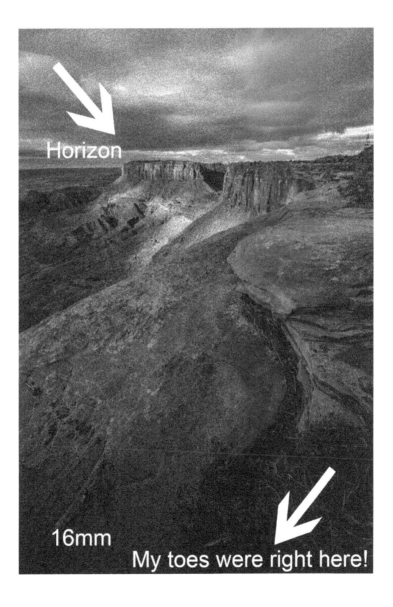

Wide-angle lenses also allow you to get VERY close to your subject and still get the entire subject in your frame. However, the subject will sometimes become "distorted" as you can see below. However, in some cases, like this, a distortion can really add impact to a photograph!

I was only about 8 inches from the car when I took this!

Medium-Range Zoom Lens

- Good all-around lens

- Perspective not skewed

- Good for basic portraits and groups

A medium all-around lens is my go-to "walk-around" lens a lot of the time. If I do not feel like carrying a lot of gear, I will use this lens and carry my wide-angle as well.

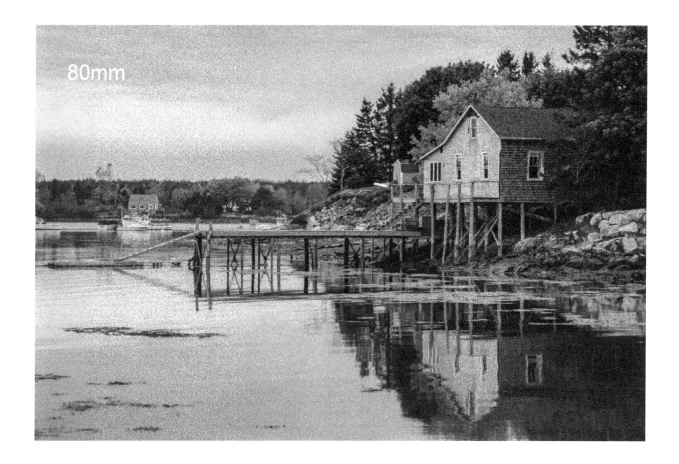

Long Telephoto Zoom Lens

- Good for sports and events

- Good for individual portraits

- Use anytime you want to get closer to a subject from a distance.

A good, longer telephoto is a must for the person photographing sporting events or wildlife. This lens allows you to get in fairly close to the action. This lens is also great for individual portraits. The reason is that just as a wide-angle skews perspective and can make people look heavier, a longer lens zoomed in on your subject tends to be much more flattering!

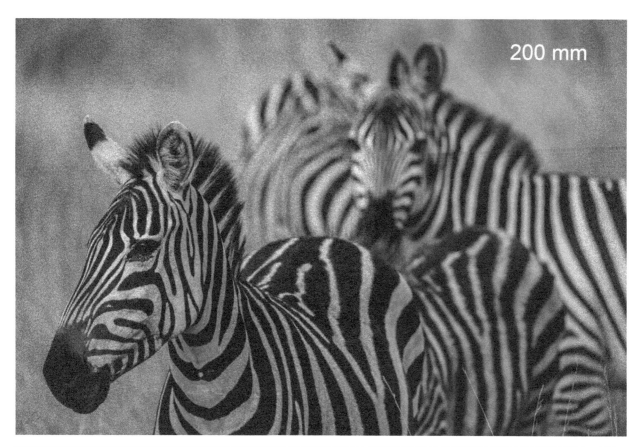

200 mm

Macro Lens

- Used for extreme close-up photography

If you love to shoot flowers, insects, and anything else extremely close up, this is the lens for you.

Fisheye Specialty Lens

- Used for ultra-wide images

- Can look like a fish eye, hence the name.

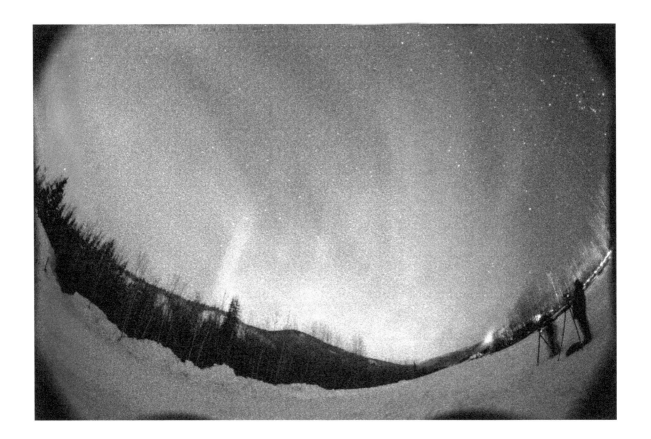

Smaller Cameras with Built-In Lenses

If you have a smaller camera with a built-in lens, you will be amazed at all that you can capture with that one lens. These cameras put a lot of lens in their small bodies. You will find you have a fairly wide angle all the way to a long telephoto all built right into your camera. Also, these cameras do really well on the macro setting, so be sure to give it a try!

Project—Photograph with the Lenses You Have

Go out and shoot with all of the lenses you have. Experiment with the various focal lengths and see what you enjoy. Be sure to use each lens you have and with the lenses, try all of the focal lengths by starting as wide as that lens will allow and then zooming in to see the various perspectives you get.

If you are using a smartphone, like an iPhone, and you purchased a set of attachable lenses, be sure to try them out here. They can be a blast!

After you have done this, read through the next compositional techniques and apply your various lenses to those techniques as you do each project.

Project—Move Your Feet!

One of the first things I like to teach students when we are out on a photography tour is to move their feet and change positions. This will help you in finding the best angles for your subject as well leading to better composition. I want you to curb the habit of what I call the "tour bus" mentality.

That is, you get on a tour bus, you get off, and you stand there next to everyone else and shoot your picture. Instead, I encourage you to take time, look around, enjoy the moment, and THEN photograph!

When moving your feet, always look beyond your subject. Make sure nothing is distracting from your main subject. I will shoot the same subject from a variety of angles. My own personal rule is that if something has grabbed my interest to photograph, I should explore it a bit before giving up on the shot. Therefore, I will shoot the same subject in a variety of ways, looking for the best of the best in an image.

Look at this photograph below. Notice that my subject is blending in with the background, thus resulting in a bland composition.

Now, simply by moving my feet, in this case moving myself to the left, I lined my subject up with the area in the back, so he no longer blends into the background. What a huge difference in the composition of photograph all because I took a few steps to my left! The photo changed from a poor to an excellent composition, which resulted in an intriguing photo.

Project—360-Degree Rule

During my career, there have been a ton of times when I became fixated on a subject, only to turn around and realize that there was a great shot behind me that I'd been missing. I have trained myself to always do 360-degree turns when shooting. More often than not, there is another shot waiting to be taken right behind you.

Below was a castle in Scotland that I was walking out towards to photograph. I was mesmerized by it! Of course I was—it is a castle on the ocean in Scotland!

As I was walking out along the trail, I stopped and took a look back towards where we had parked. I saw this scene below. I really loved the lines and sky that make up the composition of the photo. Had I not looked back behind me, I would have never got this image.

In this project, go out to a location of your choice. As you are walking around and photographing, take time to turn around and notice EVERYTHING that is around you!

Project—Rule of Thirds

The Rule of Thirds is one of the most basic composition guidelines in photography. The rule explains what part of an image the human eye is most strongly drawn to by breaking the image into nine equal squares.

The four points where these lines intersect are the strongest focal points.

Many times, people tend to place their subject directly center of their image, like in this sunset below. This is what NOT to do. The composition is expected, thus trite and even boring.

Notice that by leaving space and placing the horizon as well as the sun on the line that makes the upper third from the Rule of Thirds, the image is much more enticing.

Notice in this image, the castle is directly center. It is very common for new photographers to place their subjects perfectly center when they compose a photograph.

Now notice that by placing the castle in the upper left third and by using the leading line of the bridge (to follow what I mean by "leading line" refer to the "Leading Lines" project that you'll find after the next one), the viewer is drawn into the subject from the line of the bridge. This composition is much more pleasing to the eye as well as much more powerful of an image.

Project—Space

If subjects are moving or pointing to a side, use the Rule of Thirds when composing your photo to allow a subject "space to move into." This, in turn, allows the viewer to not feel tense when looking at the image. The image becomes more "alive" because the viewer looks at the subject as on a trajectory of movement. When you put a subject in the center, the subject becomes static and unmoving, which takes the vibrancy out of an image. So, when looking through your viewfinder and composing an image, be sure to give space to the side the subject is pointing towards.

Notice the placement of the subjects in the following images. Each subject is not centered; instead, the subject has space to move in their designated trajectory, thus making the images animated and compelling.

Again, be sure to give space to the side of the image you want the viewer to lead into. In this way, the viewer does not move their eyes out of the image and, instead, can move their eyes as they anticipate where the subject is going.

Notice the space to move into.

Project—Leading Lines

Leading lines are a compositional tool to draw a viewer into and through a photograph. Use leading lines to create much more interest in your subject by leading the viewer into the image with the lines.

Anything with a definite line can be a leading line. Fences, roads, paths, railroad tracks, and even a shoreline can lead the eye. If you can pair leading lines with a subject that is placed according to the Rule of Thirds, your image should be very strong.

For this project, go out and look for lines that you can photograph. Be sure to let the line lead your viewer into the image as in the examples below.

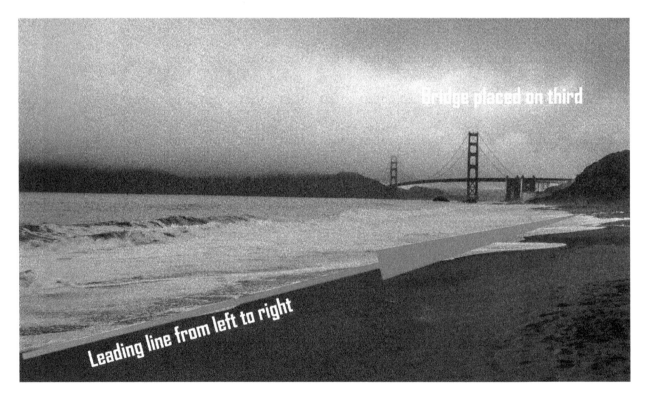

Project—Sense of Scale

Many times when I am photographing, I will purposely keep or even add something to help create a sense of scale as to the size of the main subject. For instance, below in this ice cave, you cannot tell how large it is, so there is no sense of scale for the viewer.

Now by having a person stand in the opening, the viewer gets a sense of the massive size of the cave.

The same idea applies below. In this image of a waterfall, by keeping people in the photograph, it allows the view to understand how big that waterfall really is!

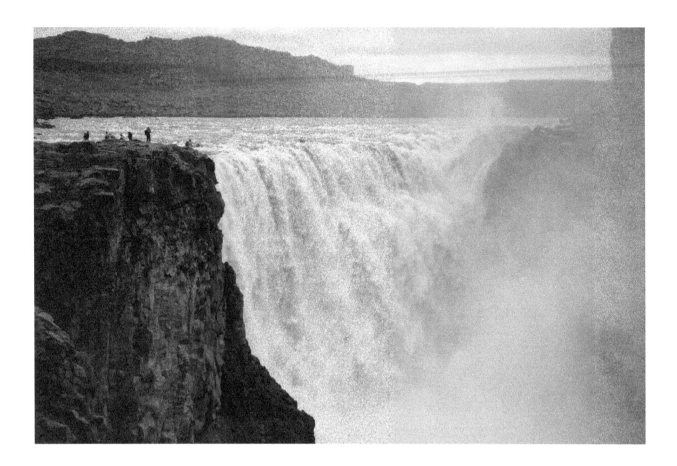

Go out and look for large subjects, such as tall buildings or large trees, and place a person next to them as you photograph. Focus on really trying to show the sense of scale by showing the entire subject, such as the full height of a tree.

Project—Natural Framing

Using natural framing to establish the composition of an image is an excellent way to give a different perspective. Look for natural ways to frame your main subject. By using natural frames, it's as if we can allow the viewer to see into another world. It is also a great way to direct your viewer toward a specific subject, as seen below. When out photographing, look for what others are missing.

Project—Curves

Curves are graceful and dynamic and add visual movement to an image. They can separate or connect elements, or simply offer a balance. Curves can help to take the viewer on a visual journey through the image. Typically in photography, we use S curves and C curves

S Curves

Some curves, like in the photos above, seem obvious while others, like below, are not always so obvious. Look at the image of the field below and see how I used the various lines as an S curve that leads the viewer through the image.

Below you can see where I have highlighted the curves.

C Curves

Many times we can use a curve to lead our viewer to our main subject. Here is another example of not just zooming in on the main subject, but allowing the viewer to visually move into the image and follow the curve directly to our main subject.

Do you see the C curve?

Now it's your turn. Take your camera and go out into the world looking for S and C curves. Start taking photographs!

Project—Walk into a Photo

When on location, I love to share with my students about how to "walk into" a scene. Now I do not mean actually walking into a scene as demonstrated with my foot in the photo above.

What I am working to create is a visual journey for the viewer to go on IN the photograph.

In the image below, look at all of the elements working together in combination. This image has a leading line, a C curve, and the Rule of Thirds; plus, by using a wide-angle lens, it allows the viewer to "walk into" the photograph visually!

This composition of the photo allows the viewer to take a journey down the road and to the castle just as if they were there physically. This gives the viewer a sense of being there and coming into the scene.

Your task is to take "walk-into" photographs. And you don't have to photograph your feet or toes to do this, but that's a great lead into helping you figure out scenes that would make great walk-into images!

Project—Patterns and Shapes

Patterns and interesting shapes are all around us. We live in a world FULL OF DESIGN. Whether it is man-made or in creation, our world offers the photographer the ability to capture design every day. Most of the time we are too busy to stop and notice some unique photographic opportunities right in our own daily lives! In this project, go out and find interesting shapes, patterns, and designs to photograph.

This image above is a bike rack.

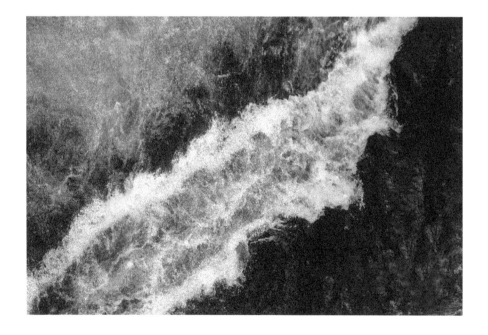

This image above is of a rushing river through a canyon.

Can you guess the animals these patterns come from?

Project—Fill the Frame

Another excellent way to train your eye is to look for interesting details rather than photograph an entire scene. In your photos you will fill your entire camera frame with an area of the scene. This is also a way to come up with patterns and designs, like in the previous project.

Take time to focus on smaller elements and patterns in the scene and see what you can come up with!

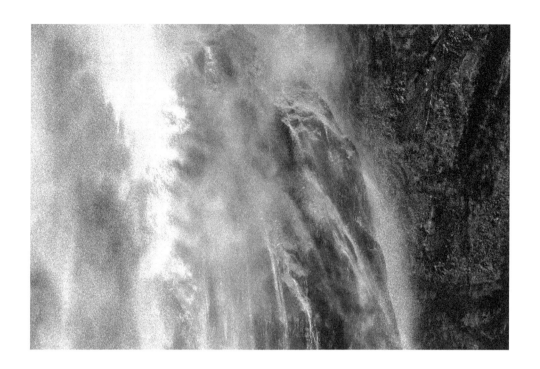

Section Four

Full Manual Settings—All Three Exposure Elements Together

WARNING—Before proceeding, full manual settings ahead!

I am about to take you into full manual settings. Some may say this is too difficult for kids. The answer to that is yes, for younger children this will be the case. As you've already seen (and hopefully done!) there is plenty to do in this book with children of younger ages.

However, I also know that there will be older kids and teenagers that can grasp full manual settings. I have seen it many times with kids as young as 9 or 10 "getting it" while their parents struggled! I have seen kids sitting and shaking their heads trying to help mom and dad figure it out! So, I feel it is worth it to add this section.

I highly recommend that you proceed learning the manual settings and do the projects below with your kids regardless. Why? Because the projects are awesome, and you and your child will love it! You can learn the settings. Additionally, I give step-by-step exposure settings to use with many of the projects that I personally think are just really cool.

I want to also encourage you that if you get through this and find you are ready for more, please get copies of my other books as they will continue to take you and your older children on a learning journey in photography. If you learn the full manual settings, you have the foundation for any books on photography out there.

At this point, you now have a basic understanding of all three of the exposure elements. Give yourself a pat on the back! Most people with great cameras never get this far—and you have!

You already know how to shoot with a faster shutter speed and control the action with shutter priority mode. You also know the same about depth of field with the aperture priority mode. Those two items alone provide you with far more control than auto or scene modes. From here on out, the very least you should be using is one of those.

If you get frustrated and are having a difficult time, you can always resort to one of those modes if need be. Again, having some control is way better than no control!

Now we are going to move forward into the aspects offering the most creative control of your camera. Are you ready? I am going to take you into full manual, and it is going to be awesome!

Light Meter

The key to using all three elements and knowing that you have the right amount of light for the exposure will be based on your light meter.

A light meter is an instrument or display inside your camera viewfinder and on your LCD readout that tells you if the amount of light reaching the sensor is correct for your exposure.

The light meter takes into account all three exposure elements: shutter speed, ISO, and aperture settings. Usually, DSLR cameras feature the light meter display on the bottom when you look through the eyepiece. It also tends to display on the top digital display or LCD screen.

Light Meter in Camera Viewfinder

Look to see what side your Plus sign and Minus sign are on.
Plus side is over-exposed and minus is under-exposed.

Unless you are using a tripod, I recommend using the light meter INSIDE your viewfinder as you are looking through your camera so that you can make adjustments while your subject is in the viewfinder and you are consistent with where the camera is reading the light from. Otherwise, the camera may take a reading of something different while you are looking at the top or LCD screen.

The idea here is to get all three elements working together to allow the correct amount of light to expose the sensor. Each element can give a different result based on what you are looking for, like stopped action, in the case of a racecar, or shallow depth of field, in the case of a flower.

When you adjust one element, you also must adjust another to CONTROL the amount of light that the image sensor is exposed to. Too much light and the image will be overexposed and bright. If there is not enough light, the image will be dark and underexposed.

TIP: Using your camera's light meter will help you to know when the adjustments for the exposure are correct.

Even when shooting on auto mode, the camera still uses the three elements. However, the big difference is that when in manual mode, you are taking control, and in doing so, you control ALL of the aspects of your image—not just light, but movement and depth too! You are in control!

In the above image, the light meter scale is set in the middle to zero showing that we obtained the proper exposure. If it were to the minus side, it would mean we were underexposed. If it were on the positive side, that would mean we were overexposed. Sometimes you may find you prefer to underexpose OR overexpose a picture to get the results you want. Remember, YOU are in control!

You may see your meter with an arrow or a blinking line to the far right or left. This simply means you are WAY off the scale and not in the readable area yet. As you move your exposure through one of the three elements, to either add or take away light based on whether you are overexposed or underexposed, it may take a bit of movement before you actually see the line moving on the scale. This is because you are so far down the scale that you may be way beyond just a few notches. Simply keep adjusting to allow more or less light in, depending on the position of the arrow or the blinking line, and eventually the needle will go solid and then start moving into position.

Project—First Full Manual Shot

Make sure you are on full manual (M on the dial, NOT the lens), and make sure your ISO is set to 100 or 400. Set your aperture to its smallest number (largest opening). Now look through the viewfinder at your light meter. If you are on the positive or plus side, you have too much light. You'll adjust the shutter speed to fix this. Reduce the light by moving the shutter speed dial to the right, which makes the shutter faster (reducing light through time value).

If you are on the negative or minus side, you have too little light. You'll adjust the shutter speed to fix this. Take your shutter speed and allow more light by moving your dial to the left, which makes the shutter slower (allowing in more light through time value).

Do these steps until you see the light meter line up in the center of the scale. CONGRATULATIONS—you have just created your first FULL MANUAL exposure.

Bringing It All Together

Now that you know what ISO, shutter speed, and an F-stop are, what do you choose first and why?

As we venture into full manual, I want you to get this one question in your head and ALWAYS refer to it. The question to ask yourself before any shoot is this: **"Is action or depth my priority?"** The answer to this question will help you prioritize what settings to start with each and every time!

Here is a step-by-step process. This will get you working in full manual, and you will soon be enjoying full creative control!

Steps to Exposure

Step 1: Choose your ISO.

As a basic rule of thumb, the first element to determine is the ISO. Always try to choose the lowest possible ISO that you can. Typically you'll start with a 100 or 200 ISO and go from there. If you find that this is not a high enough ISO for the light available in the situation, you can always adjust (unlike the old days with film). The idea is to start with the best quality image you can get without any image "noise." Then, you adjust if you need to. I usually recommend starting at the lowest ISO you think will work, and then just leaving it alone for a bit. You can always readjust later.

- Bright sun or flash—ISO of 100 or 200

- Light shade, cloudy, or window light—ISO of 400

- Dark shade or heavy overcast—ISO of 800

- Dusk, indoor, or lower light—ISO of 1600 (unless doing long exposures accumulating light)

While many cameras go beyond 1600 ISO, know that in going there you start to lose significant quality in the image unless you have a very high-end camera.

Step 2: Ask yourself this question: "Is action or depth my priority?"

Based on the answer to this question, you will know which setting you should adjust next for your exposure.

Action Priority—if you are photographing a fast-moving racecar, the answer would be action. You now know that shutter speed is what controls action as well as light. In this case, you would start by adjusting your shutter speed first. Then you simply move the aperture into place to line up the light meter.

When considering what shutter speed to use in a photograph, you should always ask yourself whether anything in your scene is moving and how you'd like to capture that movement. Would you prefer it to be completely stopped? Maybe you want to have a sense of motion and movement? If there is movement in your scene, then you have the choice of either freezing the movement or allowing it to have some motion blur.

Depth Priority—If depth of field is your priority, then you start with the aperture setting you want and simply adjust the shutter speed to line up the meter. Remember these hints.

Big number = Big depth

Little number = Little depth

Setting the aperture to f8 is generally a good rule. At f8, 80% of most scenes work; it is the sweet spot of most lenses.

Step 3: Change the ISO if you can't get what you need out of the aperture or shutter speed.

If, as an example, you want or need a very fast shutter speed to stop action and, even though you opened your aperture as far as the lens would go (the smallest number), there just isn't enough light to allow a fast shutter speed, you can go back to the ISO and increase it, so it is more sensitive to the light on hand.

Even in some outdoor situations where there is a lot of light, you can find that very little light is able to hit the sensor during an extremely fast shutter speed. This would happen if the shutter is opening and closing at a high rate, like 1/2000th of a second or more. Even with the aperture open, it may not be enough. In this case, simply increase the ISO to get what you need. Do NOT settle for a blurry picture because you're worried about ISO quality. Remember, you can always go to auto ISO if you are struggling here.

Now let's say you want a really deep depth of field. You set your lens aperture to the largest number (smallest opening) it will go. Now you set the shutter speed and line up the light meter for the proper exposure. However, you find that the shutter is really too slow to handhold the camera (1/60th of a second or less). Again, you can take the ISO and increase it so that not as much light is needed for the exposure, which would then allow you to get your shutter speed higher for handholding the camera. Remember, even if it is a natural scene and nothing is moving, the ability to handhold the camera at slow shutter speeds is very limited. This is why landscape photographers use tripods. They want to shoot at a low ISO for quality, big depth for some scenes, and not worry about camera shake if they find their shutter speed falling too slow.

Once again, the higher the ISO, the less light is needed to expose the sensor. The tradeoff is that you sacrifice quality. In today's digital cameras an ISO of up to 800 gives good results with very few issues. Above that, you really start to see the noise. The larger the images you print, the more noise will be visible. If the image is going to be small or online, noise is not as much of a factor to be concerned about. I have no issue shooting up to 800 ISO at all.

Many times, people forget that they can adjust their ISO up or down once they have no more options when it comes to controlling the other two elements. Exposure ALWAYS comes down to the three elements of ISO, shutter speed, and aperture.

To repeat: always choose ISO and then either shutter or aperture. After that adjust accordingly. This is how to get your exposures. It does take practice, but you will enjoy having the creative control you need in order to get the amazing images you know you can take!

Project—Shoot Full Manual Settings

I want you to start with a simple NON-moving subject, outdoors, and with plenty of light. This will make your first full manual exposures easier to learn at the beginning.

1. Choose a scene.

2. Make sure your camera is on the M for manual (not M on the lens, which is for manual focus).

3. Choose 100 ISO.

4. Choose an F-stop of f8.

5. Look at the light meter and line up the scale in the middle or to the 0 by adjusting the shutter speed to let in more or less light, depending on where the meter started.

6. Take your picture!

7. You have just done a FULL manual photograph!

8. Look at your settings, and if the shutter speed was slower than 1/60th of a second, you may have camera shake. If so, boot your ISO higher, and that will allow you to get your shutter speed higher!

Tripods

One of the biggest situations my wife, Ally, our team, and I have to deal with on every photographic tour is the use of tripods. It seems that no matter how much we explain ahead of time that a good tripod is a necessity for certain shoots we will be doing on the tour, people either ignore our advice or simply think they can get by with a cheap drugstore or electronic store brand tripod.

Your images, in certain lighting conditions we will be discussing, are only as good as your camera can be stable! Do NOT have an expensive camera and place it on a flimsy tripod! It will do you no good, and you will not get the results you seek.

There are many well-made, decently priced tripods available. You don't have to have the most expensive tripod. However, a $39, off-brand tripod from the local Target or Best Buy will NOT suffice. Any movement from wind, vibration, or just the fact that the tripod cannot hold the weight of the camera will ruin your images. You have been warned!

The other issue with tripods is this—do not wait until you are out on a location to learn how to set it up. Nothing can be more frustrating than a beautiful morning sunrise happening and watching people fumble around, trying to work their tripods.

Prior to going out on a shoot, learn your tripod—how it works and how to set it up easily.

Tripod Tips

- Know how to operate your tripod ahead of time.

- While shooting, always make sure everything is tightened and secure.

- Carry an extra plate attachment in case one gets lost.

- Do not twist the camera while on your tripod. Only use the tripod controls; otherwise your camera will become loose.

- As much as possible, keep one leg pointed forward towards your subject, for security purposes.

- Lower the legs of your tripod from the top down, utilizing the largest legs first.

- Only use the center pole for height if absolutely needed. It is the least stable portion of a tripod and also allows the wind to move your camera more.

- If your tripod legs are the twist-to-open type, only twist one-fourth of a turn to loosen. Tripod legs are a pain to try and get back in if they slide out. There is no need for more than small turns when loosening and tightening tripod legs.

Cable Release

When working with long exposures on a tripod, it is very important to not have any camera shake occur. Even the slightest touch of your camera by depressing the shutter button by hand can cause your image to be ruined.

In order to avoid this, a cable release is highly recommended. Inexpensive ones that plug into the camera are very affordable. For a little more expense, you can also purchase remote releases that allow you to be completely hands-free while shooting long exposures.

Be sure that your cable release has the ability to "lock open" your shutter. You will find there are times when you may want to have your shutter open for extended periods of time, long past even thirty seconds. The lock-open release will allow this to happen.

Project—Night-Time Scenes

1. Place your camera on a tripod.

2. Use a cable release or the self-timer to avoid camera shake.

3. Set ISO to 100.

4. Set aperture/F-stop to f8.

5. Adjust the shutter speed longer for more light or shorter for less light, depending on your situation and the results you are getting. Start by lining up the light meter and then adjust from there!

6. As it gets darker, make the shutter speed longer. It is okay to be using time increments even in the seconds, like 15" (15 seconds) or more, if you have to!

TIP: Plan on photographing night-time scenes starting just after sunset. Usually, about 20–40 minutes after a sunset will provide the best results with a deep blue sky. This period of time is known as the "blue hour."

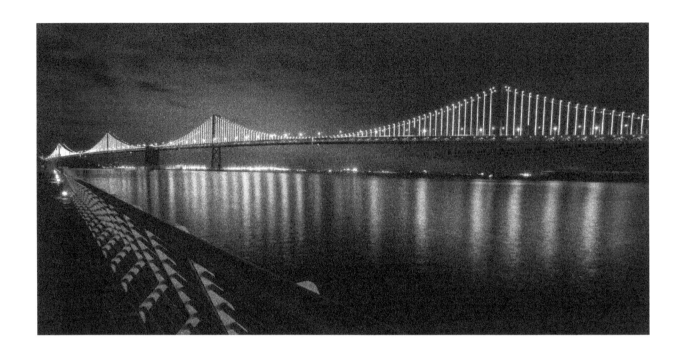

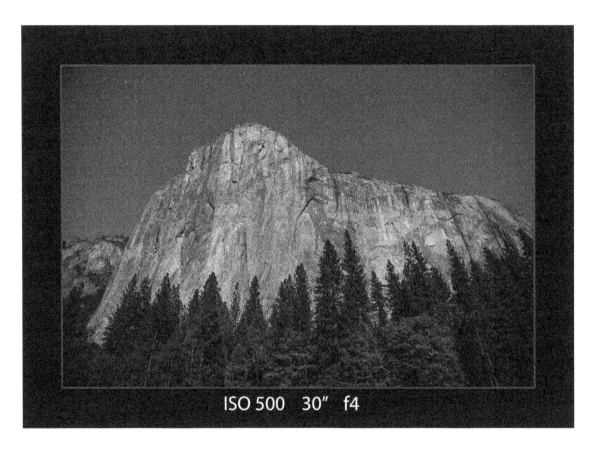

ISO 500 30" f4

Project—Car Light Streaks

1. Choose a roadside location that will have vehicles passing you by. Make sure it is dark enough that vehicles will have their lights on!

2. Place your camera on a tripod.

3. Use a cable release or the self-timer to avoid camera shake.

4. Set ISO to 100.

5. Set shutter speed to 30 seconds.

6. Adjust the aperture/F-stop for the right amount of light you need. If the image is too dark, use a smaller (wider opening) aperture to let more light in. If the image is too bright, move to a larger aperture/F-Stop number.

TIP: The reason to use 30 seconds (30") is that it allows time for the cars to go by in both directions to capture both white and red lights!

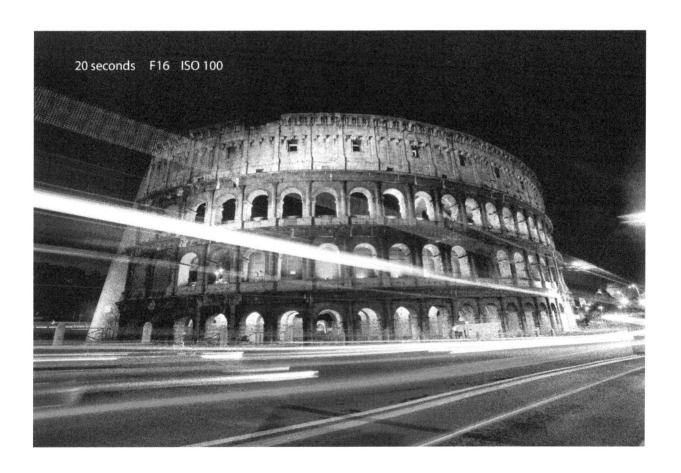

20 seconds F16 ISO 100

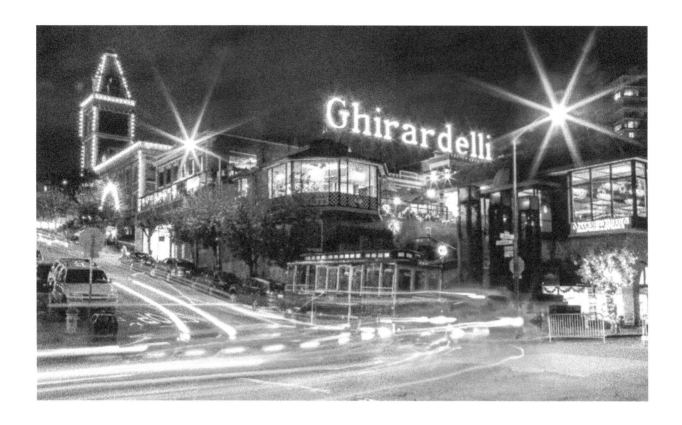

Project—Silhouette

Silhouettes are a great way to play with light. These images are not that difficult to create, but, like many things, it is a matter of someone showing you how and explaining it in simple terms.

When creating a silhouette, there are a few rules to follow to ensure optimum results.

First, make sure that you place your subject directly in front of a brilliant light source. The idea is that you are going to be exposing your image for the light source—and NOT for your subject.

If you were to expose for your subject, the result would be a washed-out, overexposed background. In this case, you want the subject completely dark. In order to do so, set your camera on manual settings and expose for the background.

I recommend starting at an ISO of 100 and an F-stop of f11 or f16. This is because we know that we want the subject dark anyway, so a starting point of a smaller aperture opening makes sense. Now, using your light meter, align it to center by moving the shutter speed.

Light Meter in Camera Viewfinder

Look to see what side your Plus sign and Minus sign are on.
Plus side is over-exposed and minus is under-exposed.

Take a look at your results. If your main subject is too light, simply make your shutter speed FASTER, which does not allow as much light in. Continue to make adjustments to the shutter speed until you get the results you are looking for. At this point, do not worry if the light meter is at the underexposed area. You are, in fact, underexposing your main subject. This is what you want.

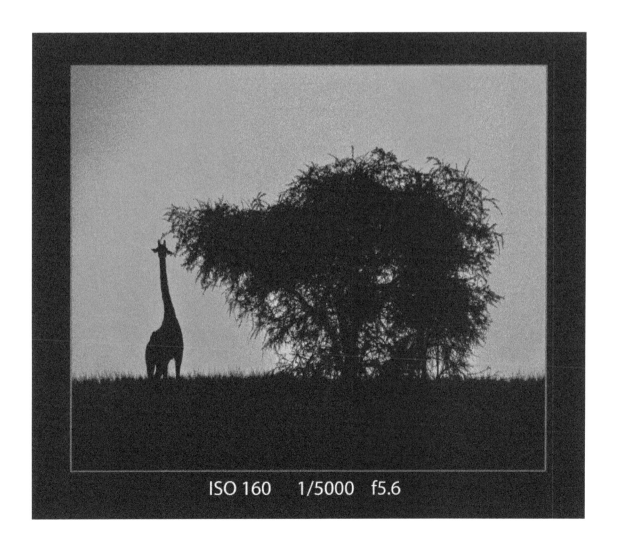

ISO 160 1/5000 f5.6

When photographing a silhouette, it is also very important to look at how the background or any areas of black are showing. If you are not careful, the silhouette can look very "blocky" with the subject blending into other areas. You really want the silhouette to have proper definition between areas, such as background and other body parts, for example.

In the image below, you can see how the subject blended into the background and is not well defined.

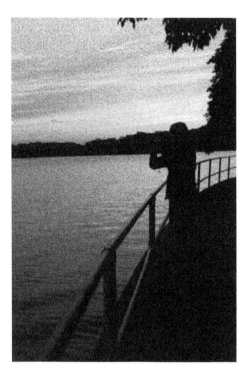

Now, by simply changing the camera angle, we get a much better result, as shown below.

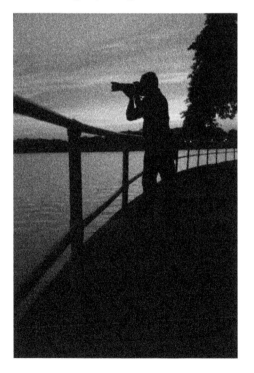

Steps to a Silhouette

1. Place subject in front of a bright light source, i.e., a sunset.

2. Expose for the bright background (NOT SUBJECT).

3. Use an ISO at 100.

4. Set the aperture to f11 or f16.

5. Adjust the shutter speed faster (less light) to get the subject darker.

6. Make sure there is a distinct separation in the silhouette areas.

Project—Crazy Light Design

One of the coolest things you can do with long exposures is to have fun with flashlight photography! Remember, it's all about light—any light! If you have a light source, you can take a photograph!

1. Place your camera on a tripod.

2. Use a cable release or the self-timer to avoid camera shake.

3. Set ISO to 100.

4. Set shutter speed to 30 seconds.

5. Set aperture/F-stop to f5.6.

6. Have a friend or family member play with lights, using a flashlight or any type of light during the exposure, and see what you can come up with!

TIP: You must turn the camera off of auto focus; otherwise, the camera will keep trying to focus and it can't in a dark situation. Turn the camera to manual focus by selecting the M on the lens for manual focus. Use a flashlight to light your subject and manually focus *prior* to taking the photograph!

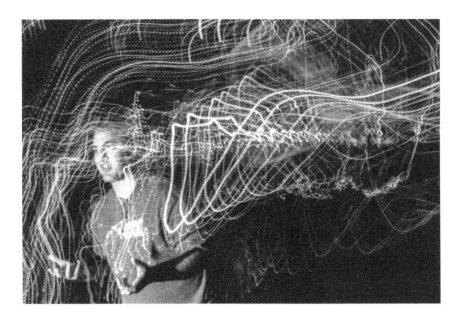

As you can see, light records no matter how dark the situation may be. The question becomes how long your exposure needs to be and the brightness of the light you are using. The idea of "painting with light" becomes clearer when you use a light source, like a flashlight, for your paintbrush!

TIP: Try all types of lights and colors and see what you can do. Be as creative as you can be!

Project—Paint Your Name with Light

Once again, painting with light can be used in fun and creative ways. Below, we had fun in the pitch-black spelling our names. When you write your name, it will appear backwards, so you need to flip the image horizontally in software to read it correctly OR learn to paint your name backwards!

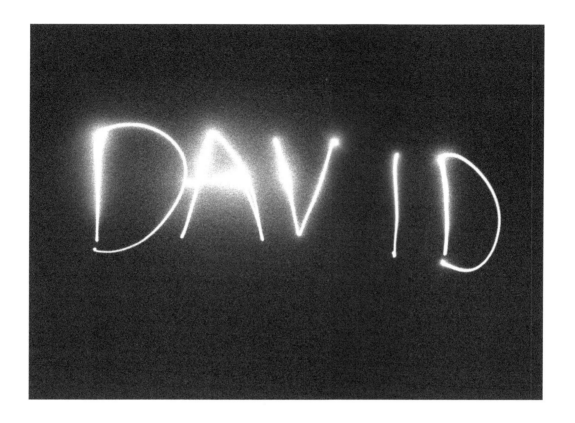

Project—Alien Attack

1. Place your camera on a tripod.

2. Use a cable release or the self-timer to avoid camera shake.

3. Set ISO to 100.

4. Set shutter speed to 30 seconds.

5. Set aperture/F-stop to f5.6.

6. Have a friend or family member pose as an "alien."

7. Have a friend or family member outline the "alien" person with a flashlight as the exposure is going. Turn the flashlight off when moving between empty space!

8. Have other friends join in the fun!

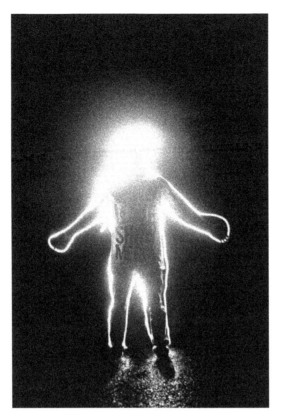

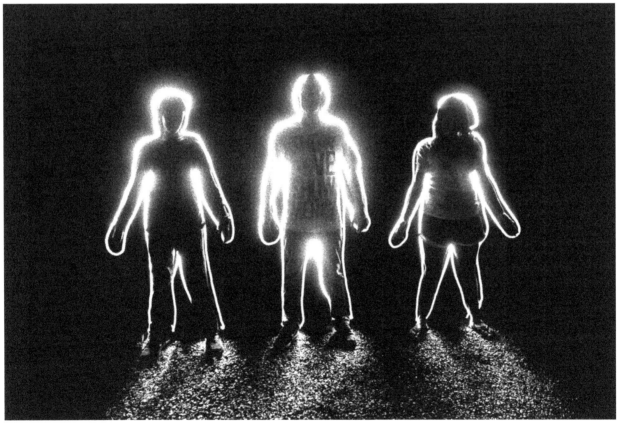

Project—Light Paint Your Parent or Friend

1. Place your camera on a tripod.

2. Use a cable release or the self-timer to avoid camera shake.

3. Set ISO to 100.

4. Set shutter speed to 30 seconds.

5. Set aperture/F-stop to f5.6.

6. Pre-focus on manual focus mode.

7. Have your parent stand in one spot and take the picture, and then "light paint" them quickly!

8. Turn the flashlight off and on, and each time it is off, have your parent move to the next position and then light paint them.

9. You have 30 seconds to get this done!

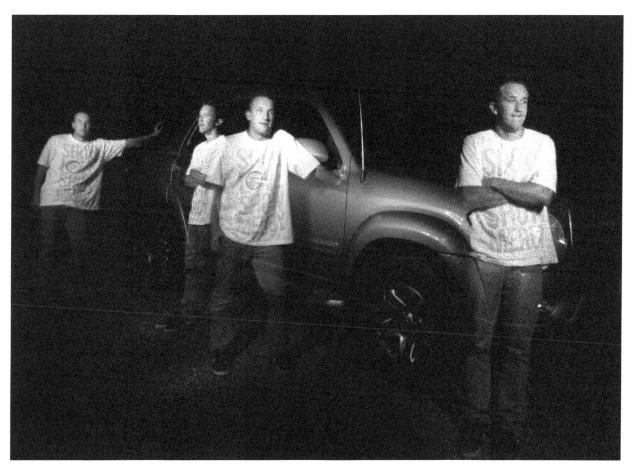

Project—Physio-Grams

1. Hang a small penlight about 2 feet from the ceiling.

2. Place your camera on the floor directly under the light.

3. Use a cable release or the self-timer to avoid camera shake.

4. Set ISO to 100.

5. Set shutter speed to 30 seconds.

6. Set aperture/F-stop to f5.6.

7. Use the auto focus to focus on the light. As soon as it is focused, turn the focus to manual, so the camera will not try to focus again.

8. Turn all the lights off (except the penlight—make sure it's on).

9. Pull the penlight back and let it swing on its own.

10. During the time the penlight is swinging, the exposure will record the pattern of the light, which will create amazing designs!

11. Try different lights, colors, and patterns!

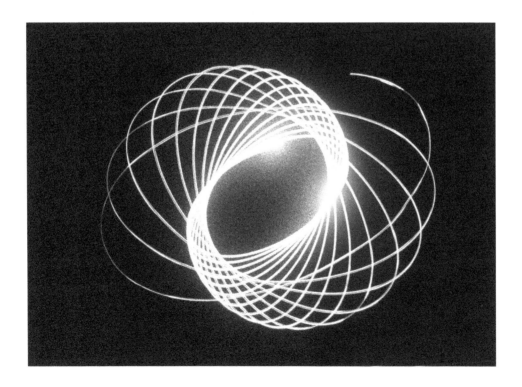

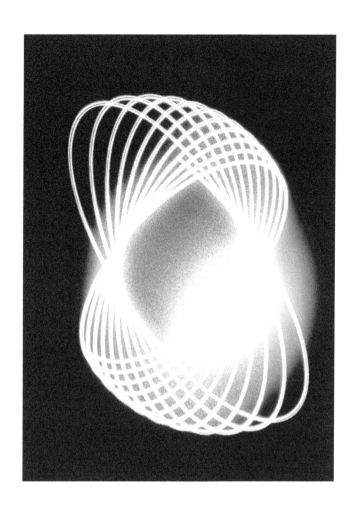

Our Very Own Case Study:

Robin and Shelby, a Mother-Daughter Super Team

Featured on the cover of the book are Robin (mom) and Shelby (daughter). Robin and her husband are long-time clients of mine, and I have photographed their family many times, including Shelby since she was 6 months old.

It has been an absolute pleasure to see Robin and Shelby start in photography—and they were part of the inspiration for this book! Robin attended a few of our classes, and then when Shelby showed an interest, they both started joining. It has been awesome to watch them both grow as photographers and to see the connection they share because of photography.

I invited them to do some of the projects in this book as a way that you, the learner, could see how an actual real-life mother and daughter created their images and also bonded and enjoyed the time together. Here are a series of four photographs they each did on an outing together.

Robin's Photographs

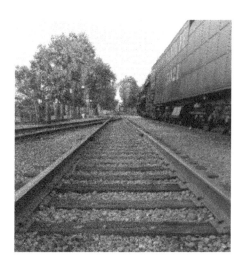

Shelby's Photographs

Do you notice how they each saw the exact same subject differently? Robin tends to enjoy the "big" picture while Shelby has a great eye and attention for the small details.

As a matter of fact, even with the other projects and photographs they did, you will see this is the case. I love that they EACH have their own unique way of seeing the world, and more than that—I love that they are getting to share this together!

Below you will see the same building, yet their totally different views on capturing it. Guess who did which one!

Here is a sunset captured by Robin.

And here is the same sunset captured by Shelby.

They also did a portrait of each other!

Section Five

History of Photography

In the mid-1820s, French inventor Nicéphore Niépce succeeded in combining a darkroom (his "camera") and a substance that was visibly altered by exposure to light, but it took several days of exposure in the camera for it to work, and the earliest results were not very good. Niépce's associate Louis Daguerre went on to develop the process known as a daguerreotype. This process, which required only minutes of exposure in the camera and produced clear, finely detailed results, was introduced in 1839 and is generally accepted as the birth of photography as we know it today. This initial version of photography was a metal-based process.

Grice, F - Circa 1855

As time went on, others learned to use chemicals and light-sensitive materials with paper and negatives. Gradually the amount of time needed to make an exposure decreased down to seconds and then even to fractions of seconds.

Matthew Brady - Circa 1865

In the 1990s the digital age was upon us, resulting in where we are now at today. By using sensors and micro technology, cameras can capture more information than ever before at incredibly fast rates.

The Importance of the Photograph

In writing about the importance of the photograph, I realize that this is a very subjective situation. Without a doubt the importance of photography cannot be underestimated, but varying views are out there as to the impact images have had on our world.

With this in mind, I am writing this part based on my own feelings and observations from being a student of photography and history, and as a professional photographer and educator for over 30 years.

Personally, I believe the advent of photography has shaped our world in ways that truly cannot be measured adequately. Whether for personal reasons, historical value, or just a record of events, photography has forever changed the way we can see the world and how we will remember it.

Personal Use

Of course, one of the primary reasons photography is so special is because it allows us to photograph and record our own lives. Moments in time that we can share with others and we can leave for others to see long after we are gone are a huge part of why photography is so important.

From its very earliest stages the use of photography to record family history and moments has been recognized. Prior to this, we had to rely solely on the written record and those that could draw or paint a moment as they saw fit.

C.M. Bell circa 1905-1909

Photographs of weddings, events, and life moments can now be cherished forever! Personally, each year I create an entire album of photographs taken throughout that year of my family. Each member of the family receives an album, and I am confident that for years and years, long after I am gone, these images will be cherished and will also provide a glimpse into our lives for future generations to come.

History

I believe that photographs are so powerful that they can change history. There is a saying that a photograph is worth more than a thousand words. Since the invention of photography, we are now able to see what would have only been told to us previously.

Of course, this has included incredible accomplishments, like the first powered flight in 1903 by the Wright brothers.

It has also included horrific events, like the Holocaust.

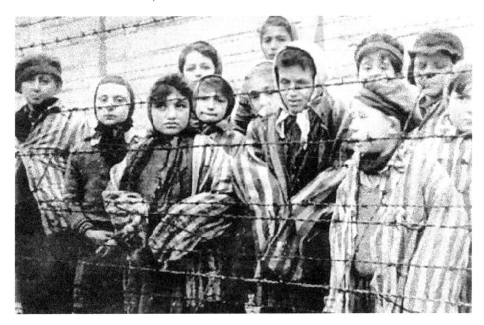

I want to ask you a question—if we did not have photographs like the one above of the children in a concentration camp, would we truly understand what took place? Would we forget? Would we then let it happen again?

You see, we must not ever forget—the good things or the bad. By having photographs, we are able to remember. Remembering is a way for us to always cherish the things we have loved and the people we have loved. It is also a way for us to learn from past mistakes and make sure those things never happen again.

The historical value of a photograph, I do not believe can actually be measured except to ask, "Where would we be without those memories and the ability to have actually seen moments in time?"

Beauty

Another incredible value of a photograph is for people to be able to see the world around them that they may never get to see firsthand. I have been fortunate and blessed to have traveled the world and seen incredible locations and cultures. By photographing these places, people, and events, I am able to share with others the beauty that is this world. For myself, I think that is one of the most incredible gifts of a photograph.

I also get to help others see that beauty and capture it. One of the things I love more than anything about photography is taking people to places and helping them to "see" and capture the beauty around them. There is something very special about taking time to enjoy the moment. By slowing down to photograph, it seems people savor those moments a bit more.

Below is my buddy Mark on our Tanzania trip. He was sharing with the local people photographs he'd taken and he was giving them small pictures from a Polaroid camera. The Polaroid prints out pictures as you take them. You see, moments like these are truly not measured in words.

The truth is, I could write an entire book itself on the importance of photography and share story after story of how I have personally seen that importance play out in my life and the lives of so many others. In fact, maybe someday soon I will!

But for now, I hope this little bit of my perspective on the importance of photography means something special to you. I hope it encourages you to see the world and all its beauty. I hope it encourages you to share with others your photographs and how you see the world, your family, and your friends. It is also my sincere hope that this book has helped you and your family bond over photography and that you continue to take photographs together.

Final Thoughts

My journey, starting as a child who enjoyed photography to becoming an adult who has made it a career, came about because of the support of my parents. My father and mother both encouraged me to find my purpose in life and to enjoy what I set out to do. They were always there for me, providing kind, positive words and encouraging me each step of the way, even when things were tough.

With their help and direction, I learned so much. Their knowledge of business, their faith in me, and their ability to allow me to find my own way permitted me to become who I am today.

I hope my life experience provides inspiration and encouragement to parents and children reading this book. Whether you are an adult with children or a child with your parents, always love each other and strive to understand, respect, and encourage each other in all your life endeavors.

It is my hope that some of you reading this book today are tomorrow's great photographers and that I have inspired you on that journey.

Never hesitate to reach out for my help. It's my greatest pleasure to encourage others as they grow as photographers.

—David McKay

Please visit our website www.mckaylive.com where you can learn all about these amazing tours and the McKay motto of:

- Photography

- Travel

- Friendship

- Adventure!

Thank you again for reading!
—David

Answers for Close-Ups in "Project—Mystery Photos"

1. Piano keys

2. Chocolate chip cookie

3. Flower

4. Orange

5. Pepper shaker

Favorite Starter Items and Gear

If you are considering purchasing new photography gear for yourself or your child, I first recommend you visit my good friend Toby's website and YouTube channel. Toby, known as Photorec Toby, travels with us extensively and is a wealth of knowledge on gear.

I also ask that you purchase your gear through his links. It is a way we help support him, which helps us have him help to support you!

It costs you nothing more to go through his links for Amazon or B&H Photo, yet it is a big help to all of us in continuing our abilities to bring the best in photographic education to you, and we all appreciate your support!

www.Photorec.tv

https://www.youtube.com/user/camerarecToby

An awesome website and YouTube channel with our friend Toby Gelston

TONS of content and TONS of gear reviews and help!

Cameras

Both Nikon and Canon have excellent starter kits that will get your or your child underway. These "kits," as they are known, come with a camera and usually a basic lens or two. These will not be the best lenses money can buy, by any means, yet they will absolutely suffice for now.

Keep in mind the technology in these cameras cost well over $5,000 just a few years ago, so for most people, this is all they need to start really enjoying and learning photography at quite an affordable price!

The Canon Rebel T series, like the T5 or T6, is my choice for the beginner not because I feel it is any better than Nikon. I do, however, find it is easier to get around its menu systems. These are well priced at around $500 to $600.

If you are looking for a camera with built-in lenses and in a budget at the $250- to $300-range, the Canon Powershot SX series is an excellent way to go. While not offering the ability to change lenses, the camera does allow for most manual setting control, and the built-in zoom lens range is phenomenal.

Taking a bit of a step up in both price and quality, both Canon and Nikon have exceptional offerings. One advantage of the Canon 70D or 80D and the Nikon D7200 is the ability for the user to use TWO separate dials for shutter speed and aperture control. This makes using manual settings much easier. By no means is it a necessity; however, eventually photographers move into systems with two dials versus one shared dial due to the ease of use in changing the settings.

Tripods

The MeFOTO tripods are excellent tripods that we recommend to all of our clients. The RoadTrip is a better way to go than the BackPacker as it is larger and more stable. Remember, any long exposures require a tripod. If that tripod is flimsy at all, the images will not be good.

https://www.thinktankphoto.com/pages/workshop?rfsn=141206.b44047

Best camera bags we have ever used! We LOVE them!

www.spiderholster.com

Great way to handle your camera! One of my favorite new items!

WHAT GEAR DO YOU NEED?

Let us ship it right to your door, business or hotel!

TAKE 5% OFF ANY RENTAL!

Use Code:
DEMYSTIFIED

All prices include roundtrip standard shipping. Only valid on rentals. Cannot be used to purchase used gear listed for sale. Cannot be used with any other coupon.

www.lensprotogo.com

For all your photography gear rental needs.

About the Author

David, along with his wife, Ally, own and operate McKay Photography Academy and McKay Photography, Inc.

The academy leads tours, classes, and workshops throughout the world. Their studio is known for high-end artistic portraiture.

David is the author of *Photography Demystified—Your Guide to Creative Control and Taking Amazing Photographs*, *Photography Demystified—Your Guide to Exploring Light and Creative Ideas*, and *Photography Demystified—Your Guide to the World of Travel Photography*, all which have become number one, international bestsellers helping to guide thousands of people in their pursuit of learning photography.

David holds the degrees of Master of Photography and Master of Photographic Craftsmen, as well as certification from the Professional Photographers of America.

David lives in El Dorado Hills, CA, just east of Sacramento, and has been a professional photographer for over twenty-nine years.

Visit the academy website at www.mckaylive.com

Connect with the McKays

- Facebook—https://www.facebook.com/mckayphotographyacademy

- Instagram—#mckaylive

Also By David McKay

Photography Demystified—Your Guide to Gaining Creative Control
and Taking Amazing Photographs!

Photography Demystified—Your Guide to Exploring Light and Creative Ideas!
Taking You to the Next Level

Photography Demystified—Your Guide to the World of Travel Photography

If you want to become a Best Selling author . . . like I have . . .

Watch the video course: https://xe172.isrefer.com/go/firstbook/dmckay22

If I can do it, YOU CAN DO IT!

—David McKay

PS—Hundreds of people are tackling their books using this three-step, FREE video course, "From 'No Idea' to Bestseller." Join them now.

CPSIA information can be obtained
at www.ICGtesting.com
Printed in the USA
BVHW02s1150260318
511606BV00011B/174/P